BRIGHOUSE
THROUGH TIME
Chris Helme

AMBERLEY PUBLISHING

Frontispiece: This 1965 map of Brighouse illustrates the town centre a few years before it went through major redevelopment during the 1960s and 1970s. Communities saw their homes disappear under the demolition man's hammer, with many old streets consigned to the history books. The new town centre bypass carved a route that many thought a waste of money, and would be the death knell for many shopkeepers. Would it really divert and encourage shoppers to shop elsewhere? Looking back on those days now, it is difficult to imagine just how the town centre would have survived without it, under the ever-growing pressures of the present-day love for the motor car.

First published 2011

Amberley Publishing
The Hill, Stroud
Gloucestershire GL5 4EP

www.amberley-books.com

Copyright © Chris Helme, 2011

The right of Chris Helme to be identified as the Author of this work has been asserted in accordance with the Copyrights, Designs and Patents Act 1988.

ISBN 978 1 84868 975 6

British Library Cataloguing in Publication Data.
A catalogue record for this book is available from the British Library.

Typeset in 9.5pt on 12pt Celeste.
Typesetting by Amberley Publishing.
Printed in the UK.

BRIGHOUSE
THROUGH TIME

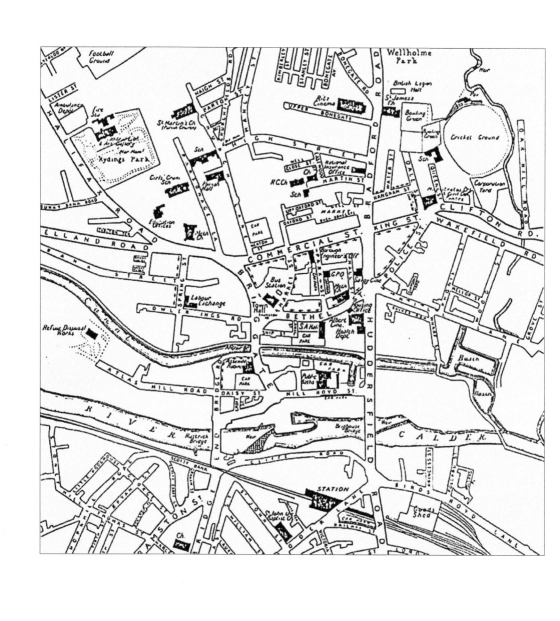

Contents

Acknowledgements

I would like to take this opportunity to thank the following people for their support and help during the preparation of this book: Derek Rawlinson, Stuart Black, the *Brighouse Echo*, the *Huddersfield Examiner*, J. C. Bates & Son Ltd (family and employees), Stephen Gee, Colin Spencer, Glyn Foster, Humphrey Bolton, Janis King and daughters Charlotte and Rachel, Michael Helliwell, Edward Field, and also for the use of the Thornton Square drawing from *Portrait of a Town*, written by the late Reginald Mitchell, in 1953; drawing produced for Mr Mitchell's book by the late Albert T. Pile.

I must also thank John Brooke and Gerald Hartley for their proofreading skills and historical scrutiny.

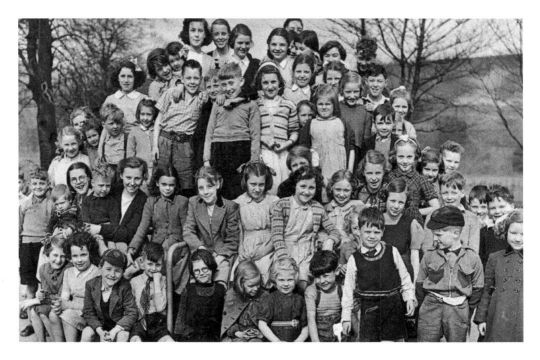

The children of the Wellholme Park Nursery in 1952, who would over the next sixty years see many changes in the wider world around them. This would certainly include many of the changes illustrated in this book.

Introduction

Brighouse was once described as a small West Riding mill town, and stands on the left bank of the River Calder. It derives its name from a collection of properties that once stood near the bridge that spans the Calder, between the much older community of Rastrick, at Bridge End. It was part of the Hipperholme-cum-Brighouse Township until it gained its independence in 1866.

Brighouse was largely an agricultural community and remained so until the arrival of both the Industrial Revolution, and the Calder & Hebble Navigation Canal in 1760. However, it was the land sale of 1811, from the Kirklees Hall estate, the ancestral home of the Armytage family, which gave Brighouse the impetus to grow. Entrepreneurs of the time were then encouraged to come to the town to build their mills, factories, create new industries, and create work for future generations alongside the two watercourses.

For almost two centuries, Brighouse had an industrial diversity that was envied by many other similar-sized West Riding towns. Throughout this period, as the mills and factories were being built, the workers also needed housing, schools, shops and of course places of worship to take care of their spiritual as well as their social needs. The town needed to develop and grow. This saw many old buildings torn down and replaced by new ones.

After the Second World War, decisions were taken that would greatly improve the lives of those returning home from the war. New housing, built fit for heroes, was the order of the day, and would be located on greenfield sites. This saw many of the old communities come to an end as the families moved to their new homes, thus creating new communities.

That scenario would be repeated a number of times throughout the town's history, but it was during the late 1960s and 1970s that Brighouse town centre went through its greatest changes. Times were also changing in the world of industry, with short-time working, closing mills, unemployment and the disappearance of many of the old and traditional industries. When the new town centre bypass was cut through, whole swathes of the town centre disappeared.

As you turn the pages of this book, it will conjure up memories for many older readers from their own childhood, and of course for younger readers it will take them on a journey through time, illustrating the many changes Brighouse has gone through.

Christopher D. Helme BEM

enquiries@chrishelme-brighouse.org.uk
www.chrishelme-brighouse.org.uk

Camm Park / Wellholme Park

Wellholme Park is vastly different from its nineteenth-century predecessor – then known as Camm Park, and still privately owned. Today, it is a worthy recipient of the prestigious Civic Trust Green Flag Award. This means Wellholme Park, Bradford Road, is in the same elite ranking as some of the nation's most famous parks. There are only twenty-six Green Flag recipients in the whole of the Yorkshire and Humberside region.

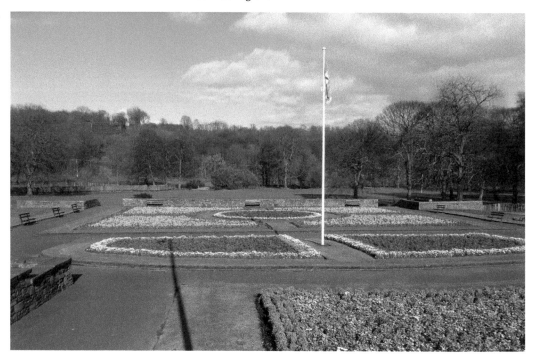

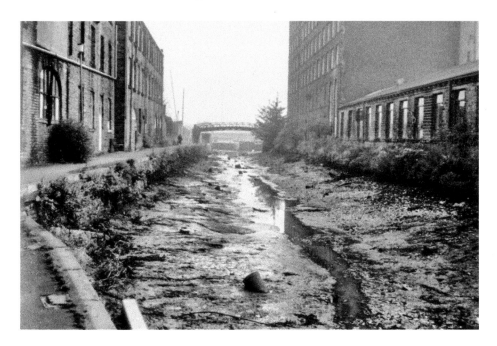

Calder & Hebble Navigation Canal

The age of the Industrial Revolution dawned in 1760, a date firmly fixed in the annals of Brighouse. It heralded the opening of the Calder & Hebble Navigation Canal, a waterway that was cut through the town to bypass the unnavigable parts of the River Calder and bring the small West Riding town an industrial heritage that was to last, unchanged, well into the twentieth century.

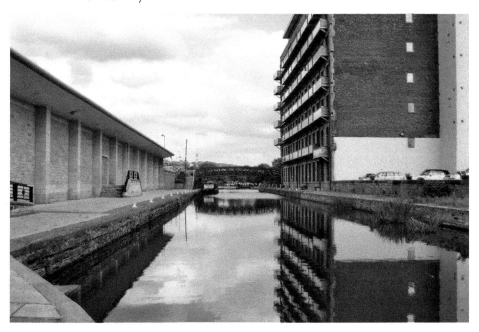

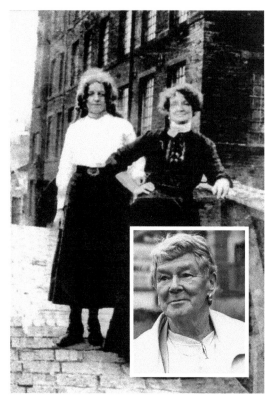

Following in My Mother's Footsteps

It is not often that five generations can meet in each other's footprints over a century apart. The older photograph is great-grandmother Emma Drake (*née* Hardy) and her daughter Gertrude Quarmby (*née* Drake), standing on the footbridge near to the Canal Basin, pre-1914. The single inset photograph is granddaughter Joyce Newsome, formerly Barrett (*née* Quarmby), who lived in Brighouse all her life until her untimely death in 2010. The ladies standing in the footsteps of their ancestral relatives include Janis King (*née* Quarmby) and completing the fifth generation are sisters Charlotte Walker (*née* Findlow) and Rachel Wilshaw (*née* Findlow).

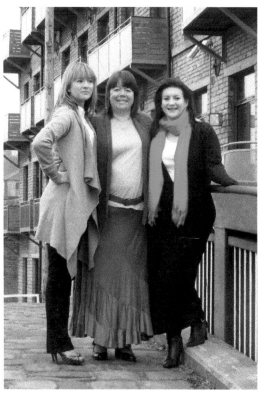

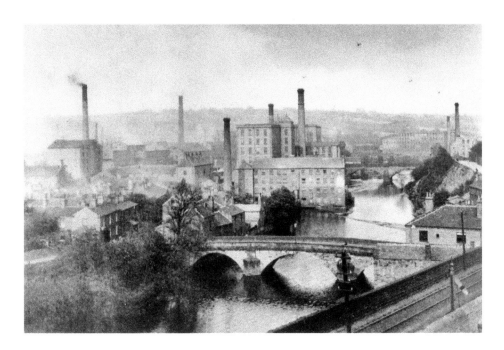

Panoramic View Towards Brighouse Town Centre

From this view, overlooking the town centre in 1884, it is plain to see that there have been significant changes in the industrial landscape. Gone are many of the tall chimneys, only to be replaced by the grain silos built in the 1960s for the Sugden's flour mill, and the modern eyesore of the electricity pylon. Many of the mills were destroyed by fire, whilst those that remain have been successfully converted into modern apartments or popular restaurants, and now even the old grain silos have been redeveloped as a new climbing gym.

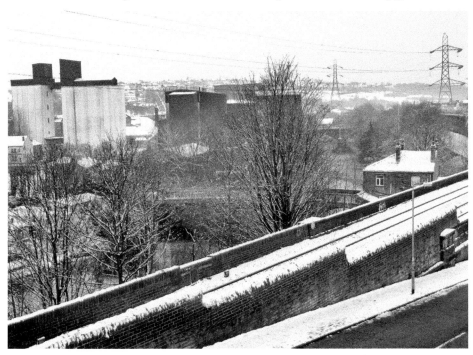

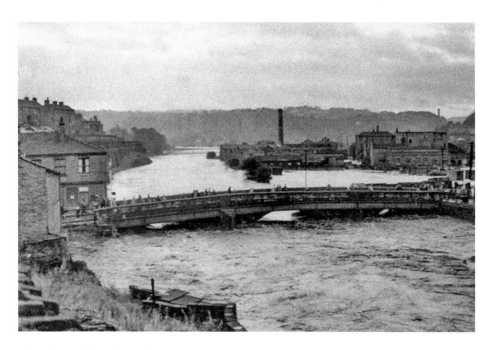

The River Calder Through Contrasting Seasons

Whilst the River Calder has served the town well. It has, however, also been responsible for some of the most heart-breaking scenes, particularly in the lower-lying parts of the town centre. The lower half of Briggate, the properties around Sugden's and the countless terraced properties in that area were always victims of flooding when the river broke its banks, as seen here in 1947. This devastation resulted in many families having to seek dry refuge in the high parts of the town. This scene is a far cry from the picturesque winter scene.

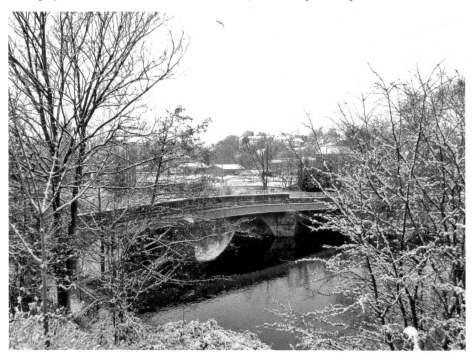

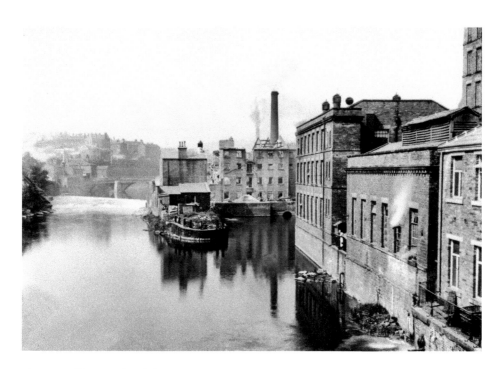

Fire – a Mill Owner's Nightmare

Most businesses have ups and downs during their history, and the flour mill of Thomas Sugden is a case in point. The business was started in 1829, and steadily brought prosperity and employment to the town for generations of families. A major setback occurred on Wednesday 14 August 1895, when, as can be seen in this rare photograph, it too, like many other town centre mill buildings, was struck by a disastrous fire.

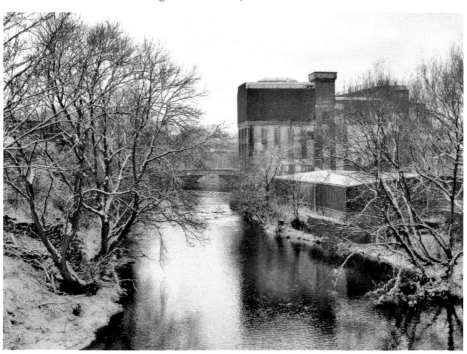

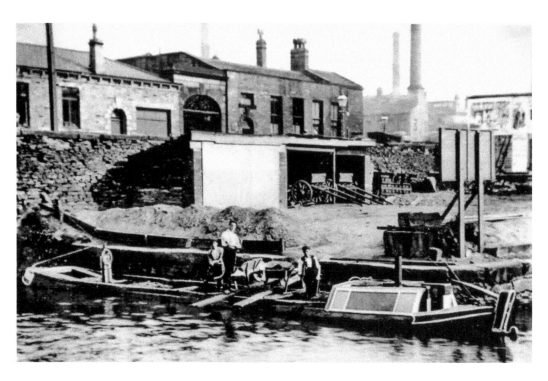

From Water Power to Electric Power

A good example of the business diversity of Brighouse. The bargemen load up what appears to be another delivery of sand, and it all takes place under the watchful gaze of a number of towering mill chimneys. This scene was set to change as this small wharf was lost when the new Borough of Brighouse Electric Works was opened in Huddersfield Road in 1909.

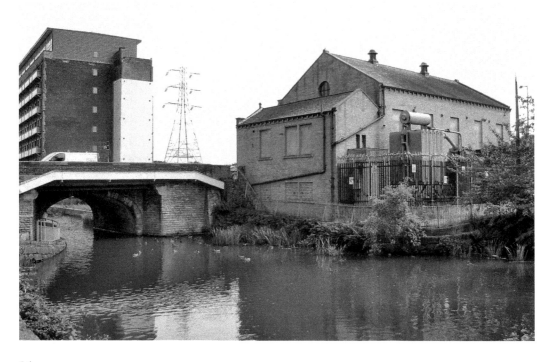

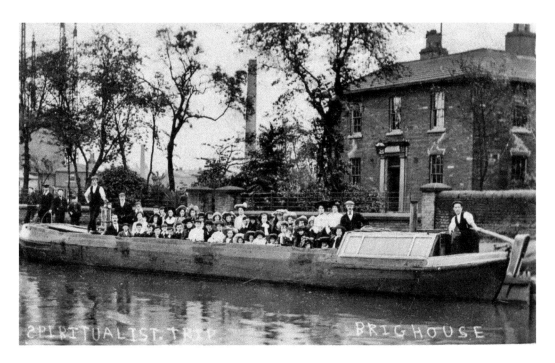

A Grand Day Out

The canal was not only used for the movement of non-perishable goods to the east and west coastal ports. Even prior to the First World War it was used for pleasure outings, just as it is here by the Brighouse Spiritualists for their annual outing.

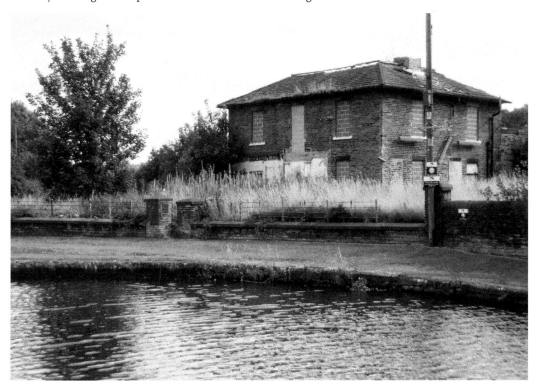

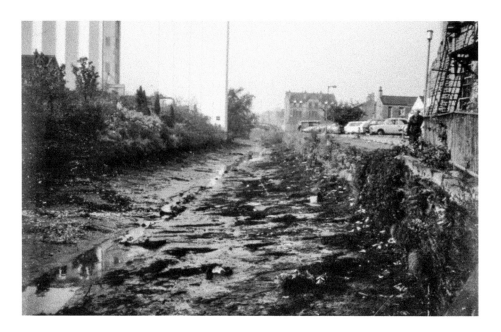

Where Has All the Water Gone?

I am sure that, like me, you will have walked alongside the canal on a summer's day, but how often have you looked at the dangerously dark, almost inviting, still waters, and wondered what *does* lurk beneath the surface? This image from the 1960s shows just what there was, once this section had been drained. Everything from old tyres, rubbish, the inevitable shopping trolley, and I dare say some cast off booty from a burglar who had been endeavouring to make a good escape.

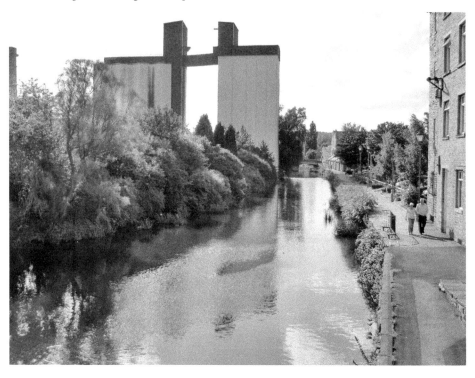

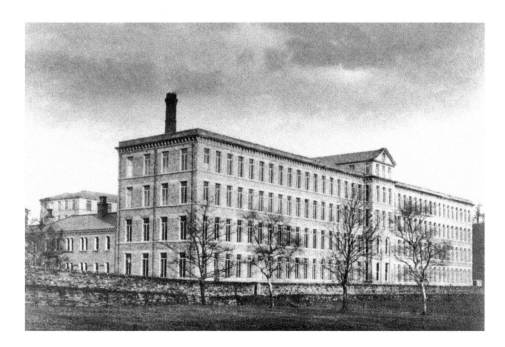

The Silk Industry

This is another of Brighouse's magnificent silk mills, built in 1882 for the uncrowned silk baron of Brighouse, Richard Kershaw. In 1903, it was bought by Ormerod Bros, but was closed down in 1975. History repeated itself as it suffered a similar fate as many other mills, when all but two small buildings fell victim to a huge fire in December 1985.

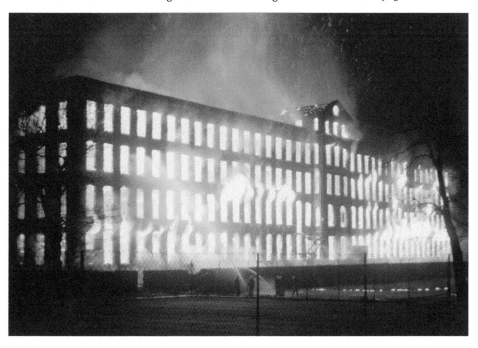

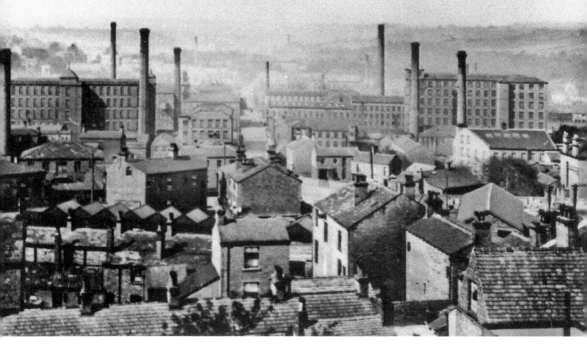

Conversion from Dark Satanic Mills to Present-Day Apartments
Looking across to the town centre just goes to show, judging from the number of mill chimneys, what a thriving industrial town it was. Today, the Millroyd Island apartments are all that remains of what was once described as Brighouse's dark, satanic mills of the Industrial Revolution.

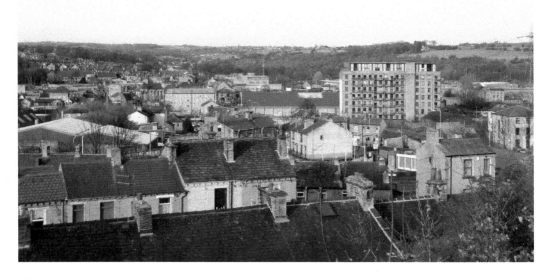

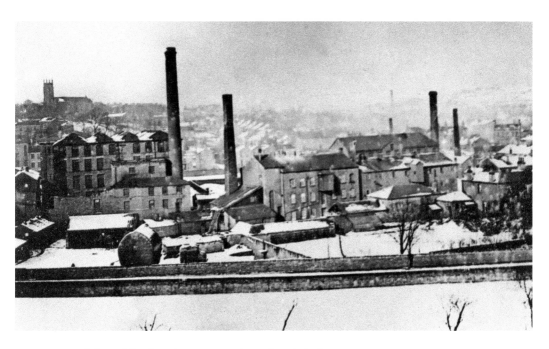

St Martin's Parish Church Oversees the Industrial Changes
The Brighouse Parish Church of St Martin surveying the town from its hilltop position. What changes must it have seen over the 125 years between these two photographs being taken?

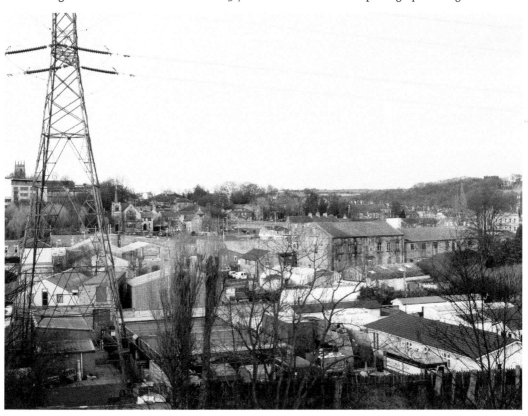

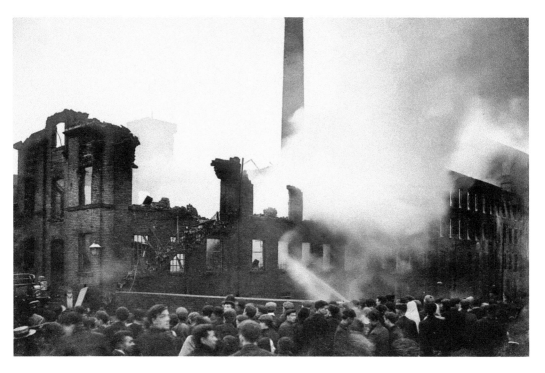

The Changing Face of Huddersfield Road

The crowds gather to watch the disastrous Victoria Mill fire of Thursday 27 July 1905. What a sight! Once the fire was out, and the removal of the top two burnt-out floors was complete, the building continued to house a number of small businesses. That was until its demolition, and the opening of a new Sainsbury's store on the site in 1998.

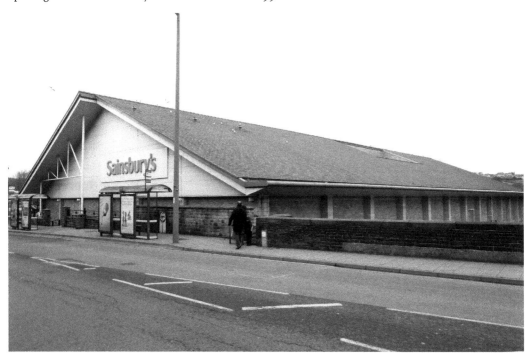

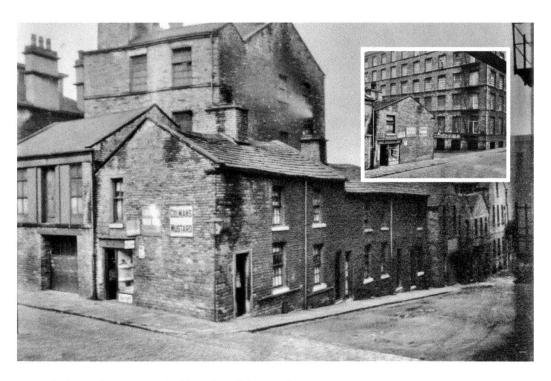

Birds Royd Lane, a Veritable Industrial Powerhouse

Princess Street, off Birds Royd Lane, is certainly not the street it once was. Gone are all the back-to-back houses, and the Prince of Wales Mill silk spinning business of Ormerod Bros at the top of the street (*see the inset*). The mill was completely destroyed by fire in 1984. Here we see it during the 1930s.

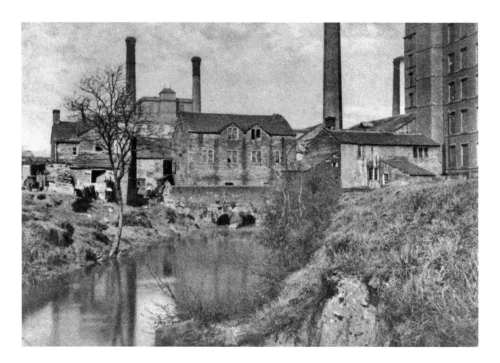

The Sun Shines on the Millroyd Apartments

These two photographs illustrate just how things have changed over the last 125 years. The two images have been taken but a few metres from the exact same location. Gone is the small artificial channel, Goit, which carried water to feed the mills. The only building that remains is the highrise mill on the right, which today is the Millroyd Island Apartments. The unsightly electricity pylon replaced old-fashioned water power, and was erected practically on top of the filled-in water channel.

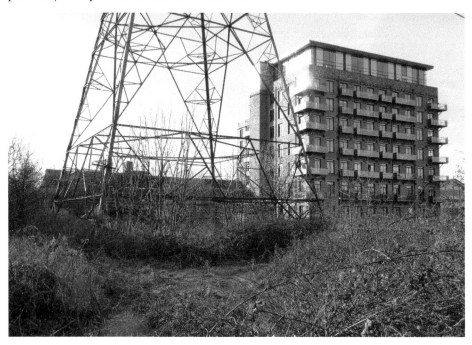

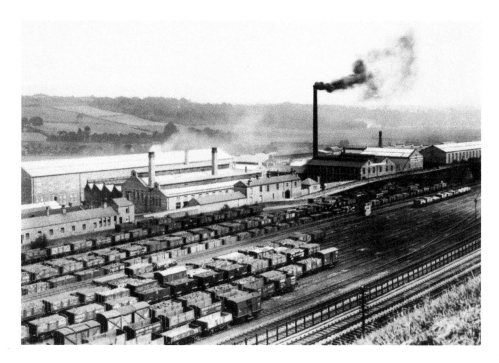

The Disappearing Railway Goods Yard

Brighouse can rightly claim to have had its first railway station before Bradford, in 1840, which was moved across the road in 1872. Its massive goods station marshalling yard was situated alongside Birds Royd Lane, a street that housed many of the town's major industries. It ensured the goods yard was always a hive of activity. In 1970 the station closed and by 1972 the goods yard had also. After years of hard work, permission was finally given for Brighouse to once again have its own railway station. This was formally opened in May 2000, but sadly the heyday of the railway goods yard was never to be seen again.

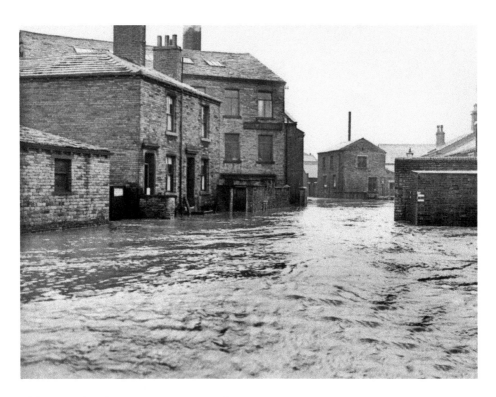

Clifton Road and Water, Water Everywhere
The 1946 floods in the low-lying parts of the town centre affected many of the countless 'two-up, two-down' terraced properties. Water filled not only their cellars but many of the old mills and factories as well. These flood waters in Clifton Road were not an uncommon sight.

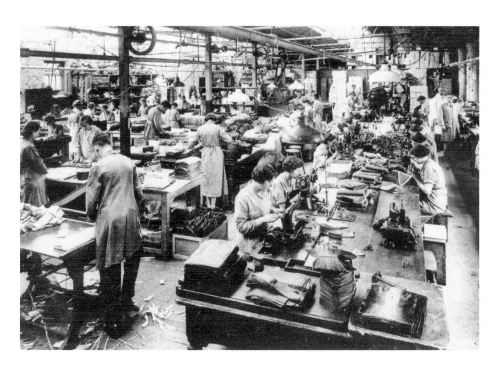

Whatever Happened to the Leather Workers of Park Row?

Gone are the days when Park Row was a hive of activity, with the main Brighouse post office on the one side at the top of the street, and the Gas Showrooms on the other. We see it here, back in the 1930s, as Sharp's leather works. Following a multitude of familiar businesses coming and going, which included a wartime British Restaurant, today it is a dry-cleaner's and shares the street with the Brighouse Rest Centre. Although these days it is a far quieter street, it is only a short walk from the hustle and bustle of Commercial Street.

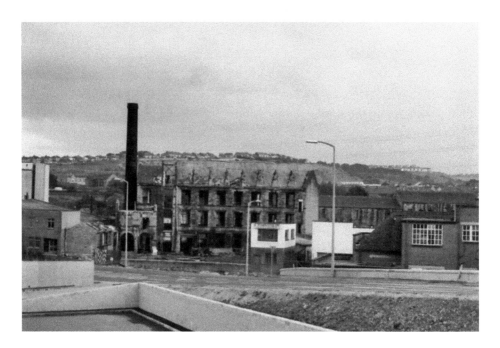

A New Car Park on Owler Ings Road

Built as a nineteenth-century silk spinner's, a stark contrast from the later businesses that occupied the site. These varied from Charles Hanson, a soap manufacturer in the 1940s, to Decosol Ltd, who were the last occupants of the mill prior to its demolition in the 1970s. There was speculation, once it was demolished, that a new bridge on the mill site would be built across the canal to divert traffic from the Anchor Bridge. Once across the canal, the new bridge would follow through to Bridge Road and then on to Rastrick. The plan never materialised, but the town centre did get a much-needed new car park.

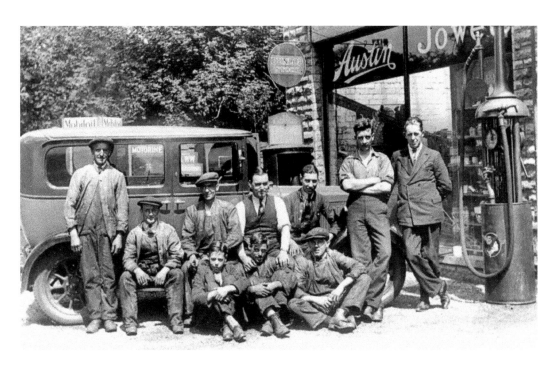

J. C. Bates & Sons Ltd – Seventy-Five Years Old and Still Going Strong

J. C. Bates & Sons Ltd has been a family business in Brighouse for over seventy-five years. Here we see the founder of the business, Jack Cocksedge Bates (second from the right), captured in a rare family photograph with his employees at his fledgling new business. Today, the business is still a well-respected family concern, seen here with the present-day family and employees.

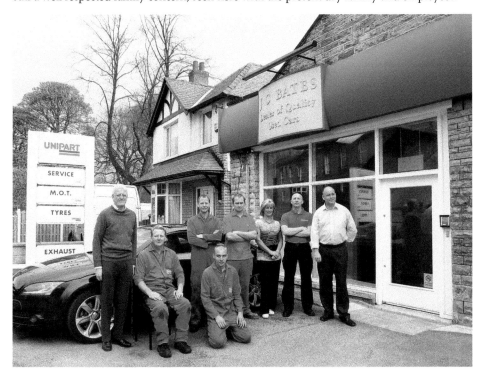

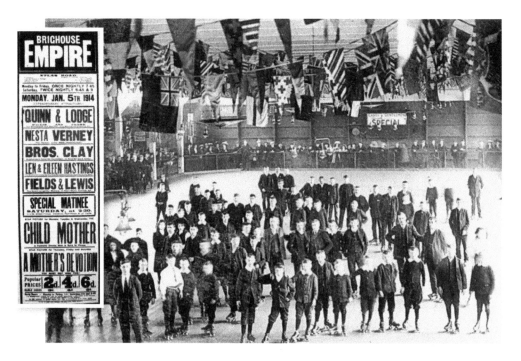

The Changing Face of Atlas Mill Road

As you drive past the council waste recycling centre in Atlas Mill Road, it is difficult to imagine that on the left-hand side, where the fairground community now live, was once the site of the Empire Theatre. The theatre advertising poster gives the names of those stars of yesteryear who were appearing in January 1914. Sadly, within four years the theatre had closed and been demolished, and remained an open space from that day to this.

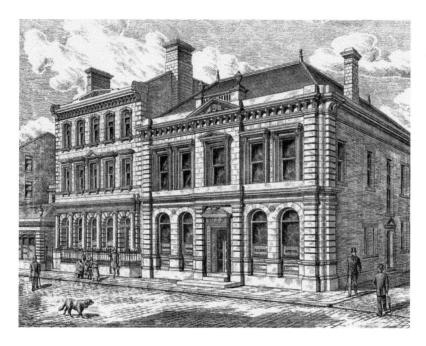

Brighouse Town Hall Overlooking the Town Centre

From the architectural impressions of the 1880s to the present day, Brighouse Town Hall has dominated the town centre for over 120 years. Note, there is no balustrade or clock on the original drawings – these were added in 1914 following a generous donation from the Mayor Robert (Bob) Thornton JP, with the clock often referred to as 'Owd Bob'. Having been sold in March 2011 to a restaurateur, a new chapter in its long history will soon open.

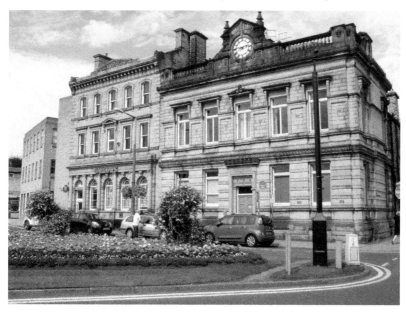

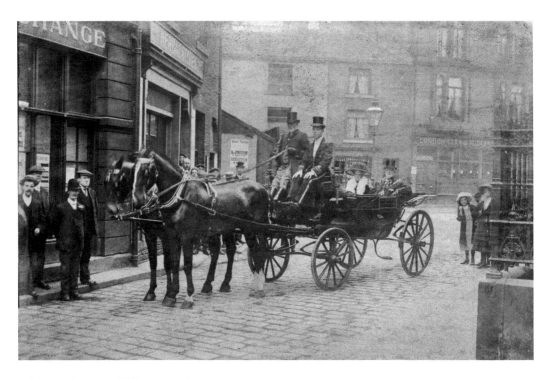

Who are the Two Children Caught on Camera?

The Mayor Robert Thornton JP and his Mayoress, Mrs Atkinson (his niece), in the mayor's carriage as they are about to depart for their next engagement. I wonder who the small children are that appear to have just sneaked into the photographer's lens, in what has turned out to be for them a true snap shot in time?

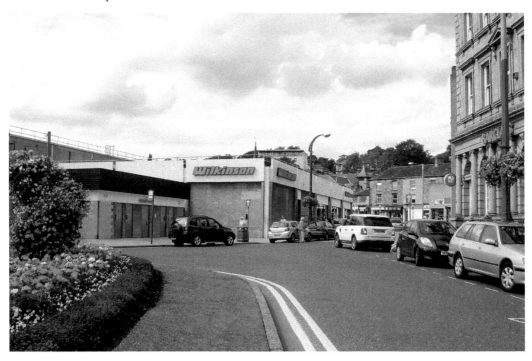

Out with the Old and In with the New

The Old Malt Kiln gable end, still visible on the left-hand side, would date this image *c*. 1885. During the summer of that year, it was demolished to make way for the new town hall. The shop next door was No. 23 Bethel Street, and was trading as T. (Tom) A. Fox, stationers and newsagents. Here, a few customers stand outside, including future mayor and alderman David Crowther Holmes, probably discussing the merits of the town centre changes about to take place.

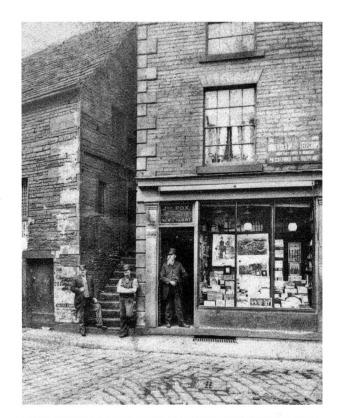

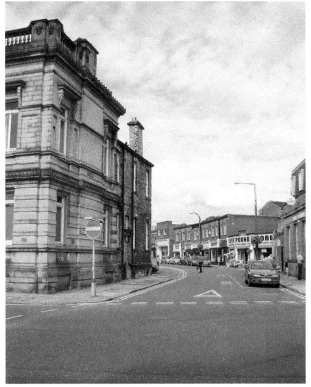

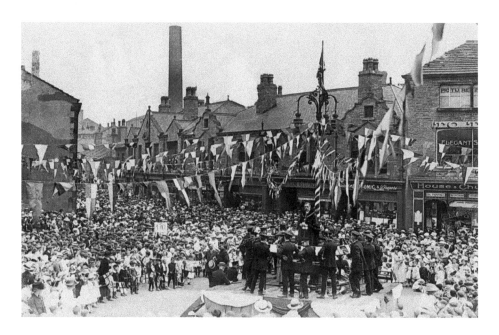

A Wartime Celebration and Commemoration

Throughout its history, Thornton Square has been the focal point for many gatherings. It has seen many happy, as well as sad events commemorated. These have included recruitment during the First World War, and presentations of the Brighouse Medal – an award for those fortunate enough to have returned home from the war. Then there have been parades of every kind, including the triumphant return of the Brighouse & Rastrick Band, following its many successes in both national and major competitions. In this photograph, there is the commemoration that the Great War is finally over, with the Brighouse Temperance Band (becoming the Brighouse & Rastrick Band in 1929) performing on the bandstand.

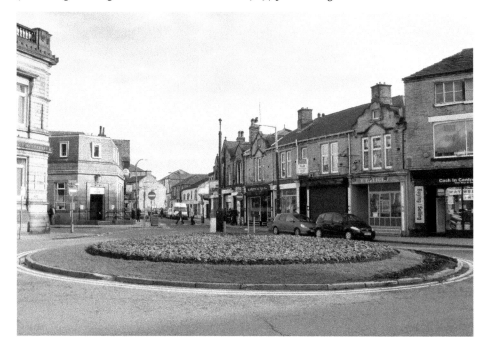

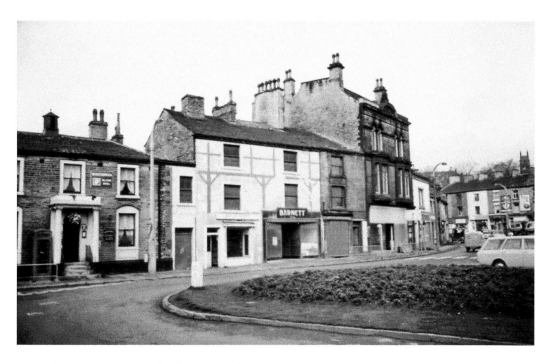

Thornton Square Redevelopment Scheme

It has often been said that the town centre has barely changed, but looking at these properties in Briggate, only the Black Bull remains. Familiar names known to generations of town centre shoppers were all demolished in the 1970s. I am sure many readers will recall the little sweet shop that saw countless schoolchildren visiting whilst on their way back to school from the swimming baths, or before they caught the next bus home from school. The delights of the 'Penny Tray' were a must.

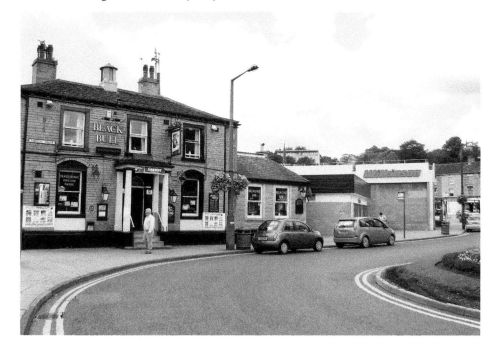

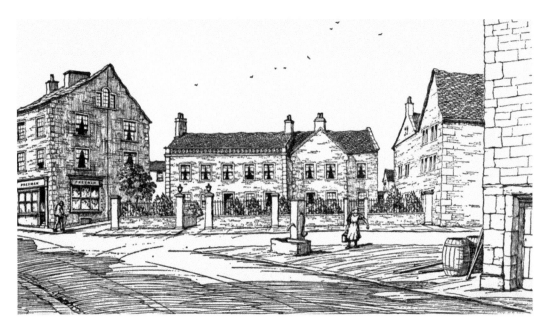

The Halifax Commercial Bank, a First in Brighouse

The Halifax Commercial Bank established its first branch in Bethel Street. It was opened in the old Manor House, the home of John Bottomley, the head of a prominent family in Brighouse. In 1875, the present-day bank was built and in 1920 this bank was merged with Martin's Bank, becoming a branch of Barclays Bank in 1969. In 1865, Brighouse had its first bank robbery, when a burglar entered the new bank premises. Although no money was stolen, the police caught the offender after he had climbed out of the window and attempted to run away. Note the Parish Pump in front of the house.

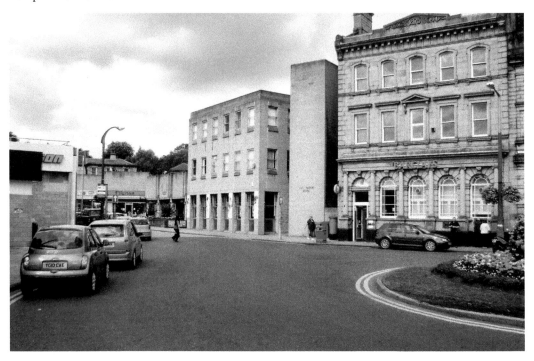

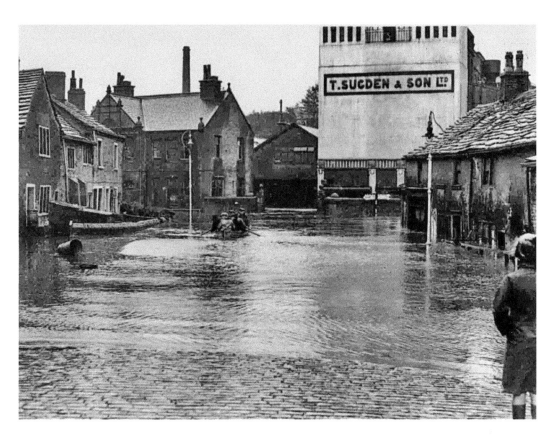

Rowing Boats to the Rescue
The lower end of Briggate always suffered flooding, being one of the lowest lying parts of the town centre. This resulted in some occasions where the only mode of transport was the use of rowing boats.

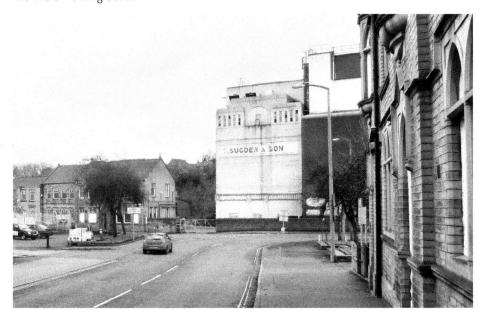

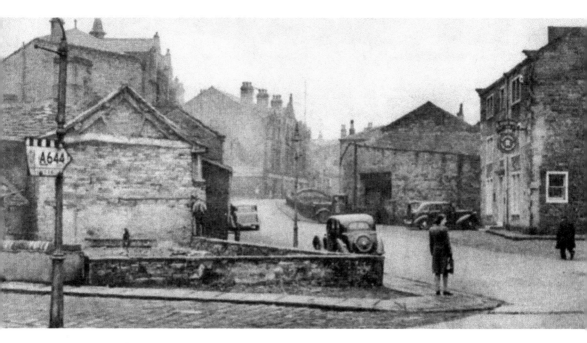

Not Even the Co-op Coal Yard Survived the Demolition Man's Hammer
If you look closely at these two photographs, you can see that the present Black Swan is one storey lower than the older image. It was cheaper to take the top floor off than have to rebuild it entirely. The building to the left of the public house is the old Co-op coal yard, which received its deliveries straight from the passing coal barges that travelled the canal daily.

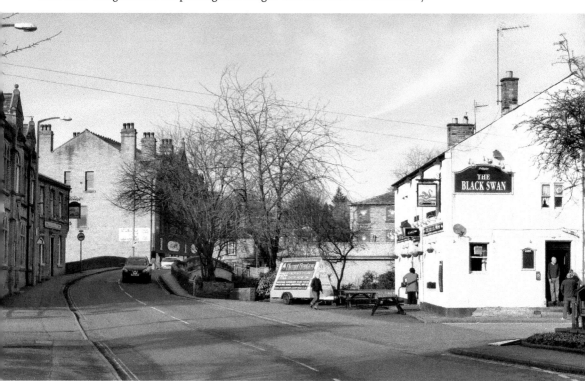

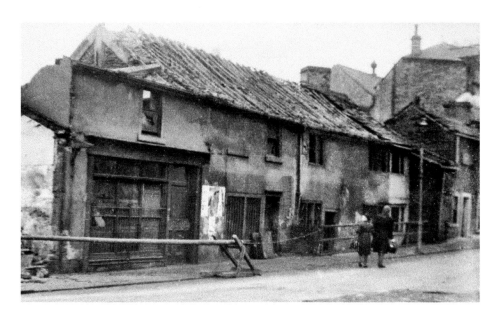

The Changing Face of (Lower) Briggate

The changing face of Briggate, *c.* 1949 demolition of the Daisy Croft area. It was in this property that a child, whilst visiting his grandmother in the 1890s, found a quantity of human bones, as a complete skeleton, in the roof space (loft). The police attended and the bones were removed, which sparked a major investigation. It was reported by what forensic investigation there was at the time that the bones *were* human, but approximately a hundred yeas old. Further investigations revealed they had in fact belonged to a doctor who had lived at the house in the early nineteenth century, and were the kind of thing a doctor's surgery had in those days.

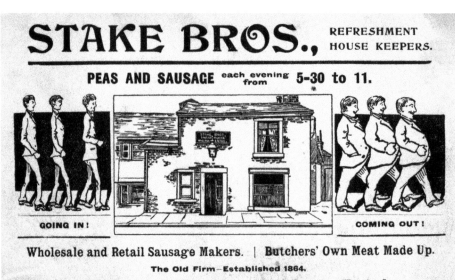

STAKE BROS., REFRESHMENT HOUSE KEEPERS.

PEAS AND SAUSAGE each evening from **5-30 to 11.**

GOING IN! COMING OUT!

Wholesale and Retail Sausage Makers. | Butchers' Own Meat Made Up.

The Old Firm—Established 1864.

72, Briggate, & 6, Huddersfield-rd., Brighouse.

'A Ha'poth, Two and a Muff'

'The Bow Window' was once described as the first takeaway in Brighouse. Originally dating back to 1864, when it was run by a lady who was affectionately known as 'Sausage Sarah'. She established the business with a reputation par excellence for her home-cooked peas and sausage. It really came into its own when it was bought by the Stake family, and run by Helliwell and his younger brother Harry. In October 1959, after a lifetime of serving the 'a ha'poth, two and a muff', or, to the uninitiated, 'a half penny worth of peas, two sausages and a tea-cake', it finally came to an end.

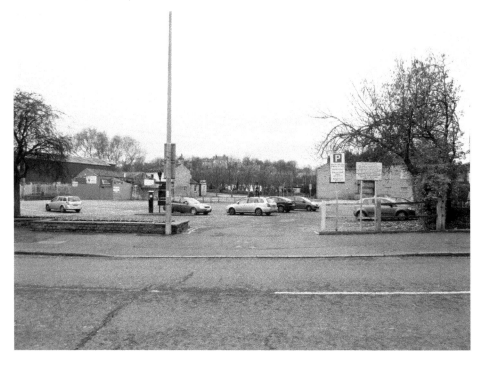

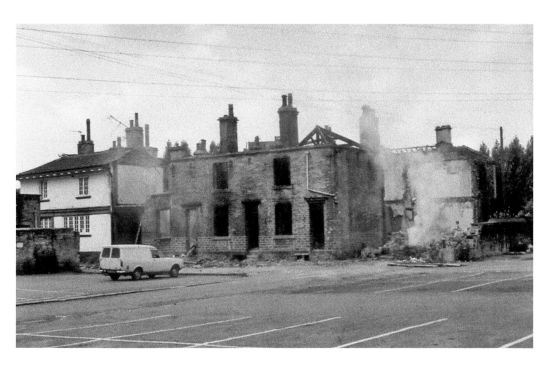

Daisy Street and Croft Street

Looking across what was Daisy Street, toward what remains of the nineteenth-century housing in Croft Street. There were approximately thirty properties demolished in this area during the early 1970s, all having been described as uninhabitable.

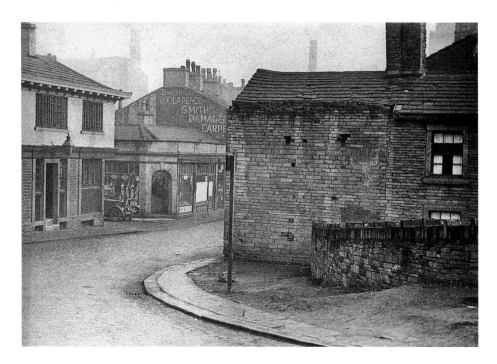

The Bridge Tavern, or was it the Blazing Rag ... ?

Things have certainly changed on this corner of (Lower) Briggate, with property on both sides of the road having been demolished in the early 1970s. The white-painted building was the Bridge Tavern, opened originally as a beerhouse in the nineteenth century and today rented out as private flats. For many years it was nicknamed the Blazing Rag, and was the only hostelry without an external door. Why? Because it had a roller shutter, truly a first in the licensing trade.

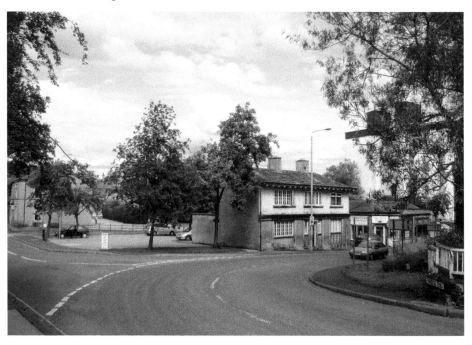

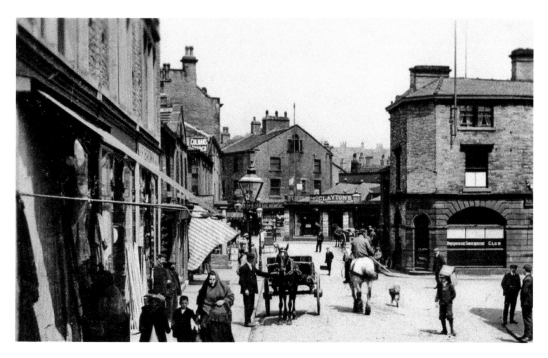

Briggate – Back in the Days When Horse Power Ruled

Looking over Anchor Bridge towards Holroyd Buildings – property that was demolished in 1914, where the vacant site became Thornton Square – with the sunblind down over the windows of John Francis Brown's hardware shop. This is a name still remembered today, but to younger generations it is Odd Jobs, a business where quality of service still counts in the J. F. Brown tradition. Note which side of the road the horse traffic is on!

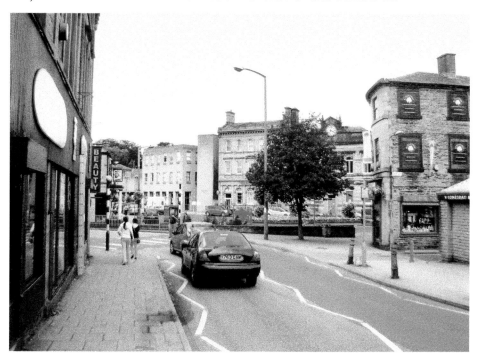

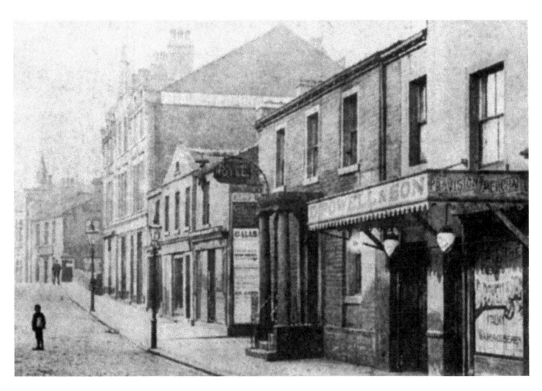

The Black Bull – The Oldest Hostelry in the Town Centre

Today, the Black Bull Hotel is the oldest hostelry in the town centre, dating back to the mid-eighteenth century. It is difficult to imagine, these days, that at the back of these premises was a cricket field and a place where large community events were held.

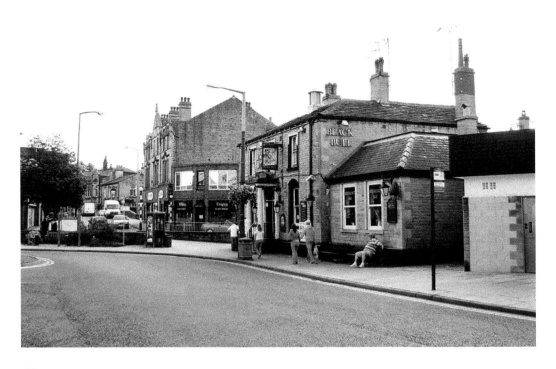

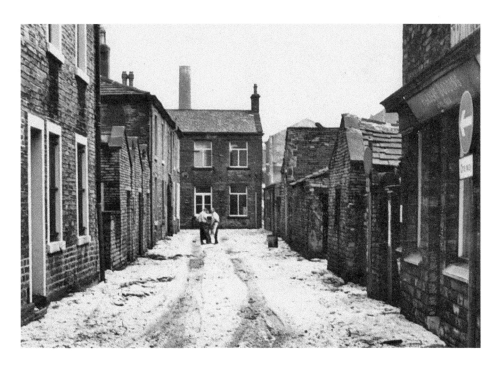

Ship Street – Small Back Street, Interesting Past

This snow-lined 1960s road was known as Victoria Street in 1907, but today it is the more familiar Ship Street. The name is derived from the Ship Tavern, which was at number 5, and dated back to the days of the old nineteenth-century beerhouses. It served its last drink and closed its doors on 31 July 1936. Its original name is likely to date back to the proclamation of Queen Victoria of 1837, but when the name was changed remains a mystery yet to be solved.

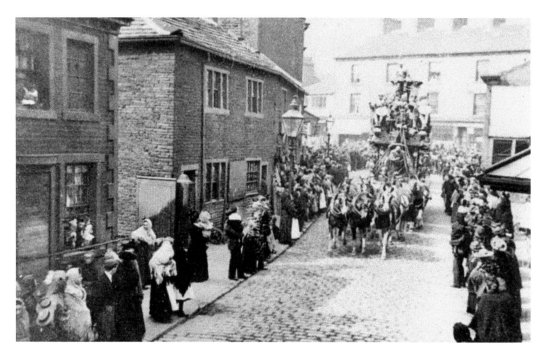

Briggate – the Street Lamps are Still on the Same Spot

There was no need to worry about overhead cables in 1907 when the Demonstration Parade wound its way through the town. Please note where the street lamps are in both photographs – lamp styles may change, but both lampposts appear to have been erected on the same spot.

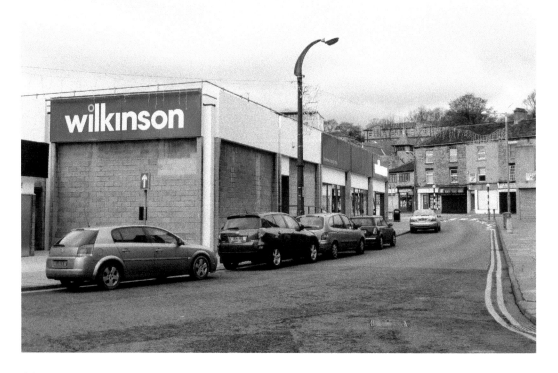

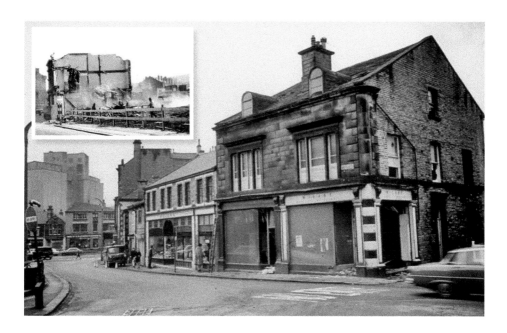

The Top of Briggate Before the Demolition Man

The town centre redevelopment programme of the early 1970s changed many parts of the town, almost beyond recognition. One of these areas was Briggate, with many of the older, familiar buildings and businesses being swept away. Many of the older established businesses never re-opened after they were demolished and disappeared forever. How many readers can recall Bower's Library on the corner, which became Willart's car accessories, and Helen's, which another generation may recall as Powell's? Lower down were Pollard Ives, Earnshaw's, Renshaw's and many more. As each one fell under the swing of the demolition man's hammer, a small piece of town centre history was lost.

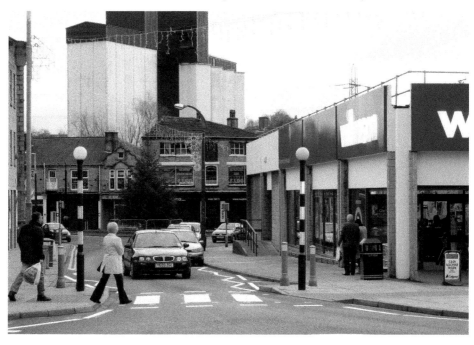

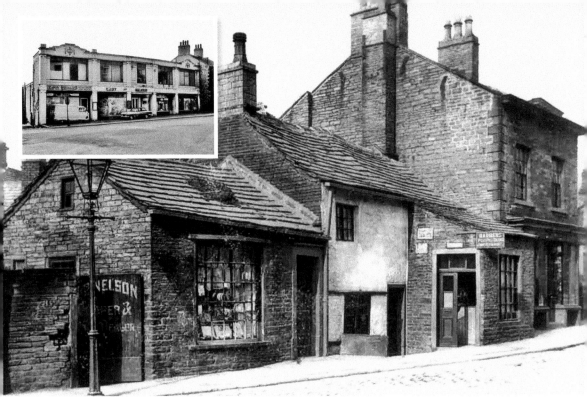

The Astoria, Once a Mecca for Brighouse's Youth Culture

The relative calm of Wilkinson's town centre car park. This corner of the town centre has had a colourful history. The older of the scenes (*top*) is pre-1905 and was the scene of violent activities in 1882 during the Irish Riots. It was through the gate behind the lamppost that the mob broke in to steal wood to use as clubs to beat up Irish men living in the town. In later years, this corner was the home of the Astoria Ballroom (*inset*), a venue many readers will recall from their postwar teenage years.

Halifax Road to Commercial Street, Market Street and Park Street

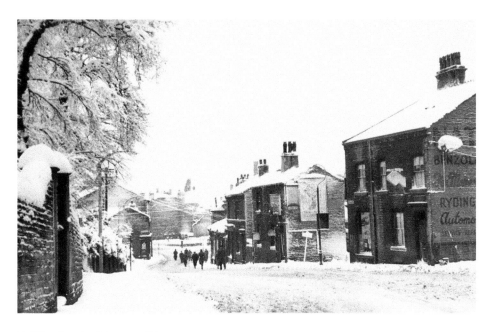

Halifax Road – Mystery Trippers

The very mention of Davison's Coach Company garage, at the top of Spring Street in Halifax Road, evokes memories of those day trips to Blackpool, Scarborough, and the inevitable mystery trips that tended always to be to Bolton Abbey. Yes, I am sure you remember them too. Then, as always, you would call in on the way back home for the usual mystery fish and chip supper, courtesy of Harry Ramsden's.

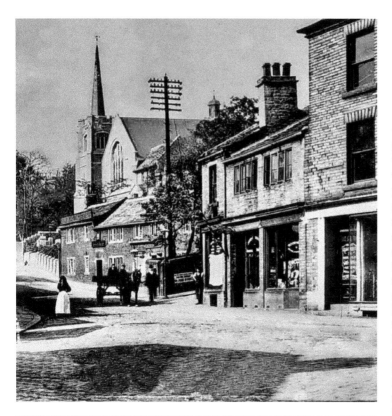

The Sun Dial Enjoying Quieter Times

The Central Methodist church has stood overlooking the town centre since 1907. The small building in the foreground has a much longer history, dating back to at least 1741. This was the home of Mary Bedford's Charity School, the first of its kind in the town. David Heaton was the first headmaster, followed by his son Isaac, who was at the school until it closed in around 1860. In 1882, it was the Sun Dial Inn, attacked during the Irish Riots that occurred following the assassination of Lord Frederick Cavendish, in Dublin's Phoenix Park, on Saturday 6 May of that year. It was eventually demolished and a decorative floral sundial was planted in its place.

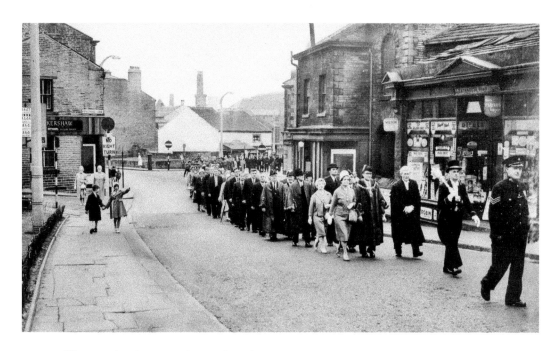

Halifax Road – the Mayor's Parade 1961

The appointment of the new mayor was always a highlight in the town's calendar. During the life of the Brighouse Borough Council (1893–1974), there were forty-two mayors, which included just two female appointments. These were chosen from a total of 285 councillors (twelve female councillors). Although few attained the appointment as the town's First Citizen, sixty-six were appointed as an Alderman of the Borough. Once the appointment had been made, there would be an official 'Mayor Making' day, which would involve a church service. Here you see the new Mayor, Samson (Sam) Williams JP (1961–62) leading the procession to his Mayor Making church service in Halifax Road.

Where Have All the Cobbles Gone?

Parsonage Lane was the direct route to the parish church vicarage. It was later sold to become a care home for the elderly but has now been turned into private residences. The road was cut in half, following the completion of the new bypass in the early 1970s, and the only access across the new road is with a passage constructed under the road. The Central Methodist church has stood at the bottom of the road since it opened in 1907, whilst all the houses on the right were demolished for access into a new town centre car park.

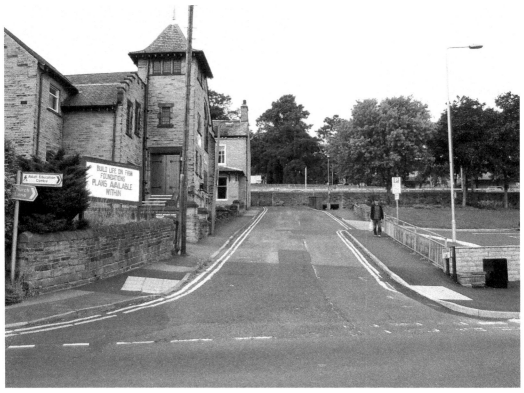

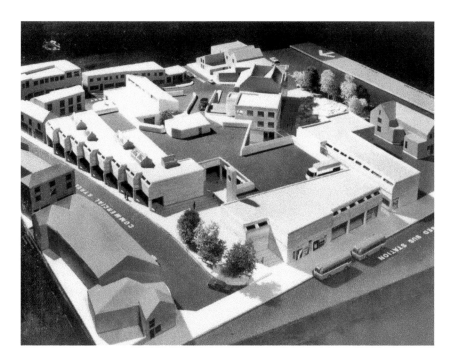

The Planner's Hopes and Expectations of the Late 1960s

This planning department model showed how the town centre would look once all the redevelopment work had been completed, with a new Hillard's supermarket at one end of the town, the Co-op at the other end, and the new bypass. Many of the established, independent, town centre shopkeepers said it would be devastating for those shops left in the middle.

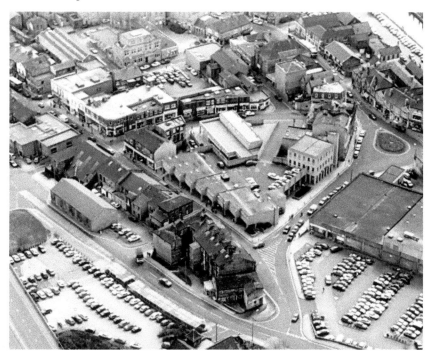

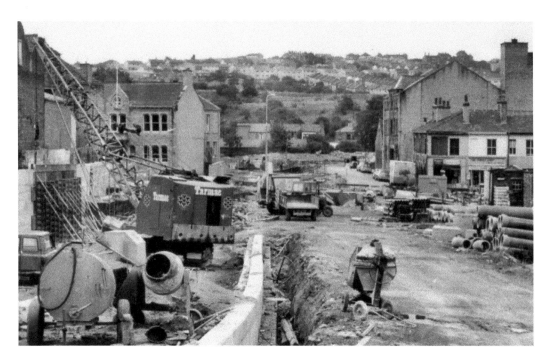

A Bypass Few Wanted at the Time, but What Would They Do Now Without It?

The town centre bypass was subject to heated debate when it was first suggested, and even more so when it was rumoured it would cost £17.5 million. 'A waste of money' was the cry from almost every quarter. It is now almost forty years since it was first opened, and with the rise in the popularity of motor car usage during those years, no one complains about the bypass these days.

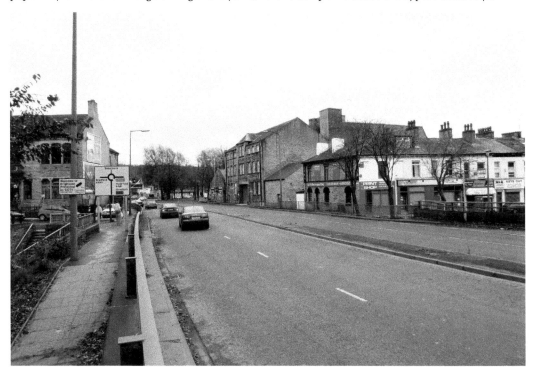

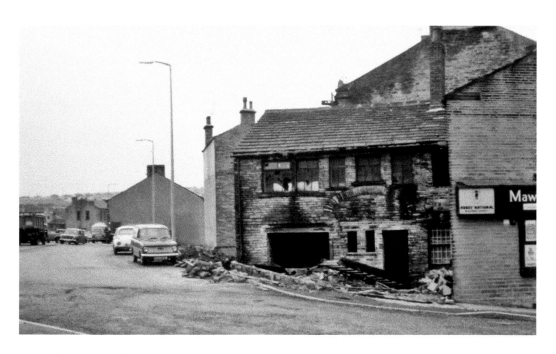

The Bottom of Parsonage Lane

This new road, which leads to the bus station, was a major part of the 1970s town centre redevelopment, and cut its path through a number of old Victorian, terraced streets. One of the few properties to survive was this derelict building at the bottom of Parsonage Lane. This property has been a sewing shop, and for a number of years it has been an estate agent's.

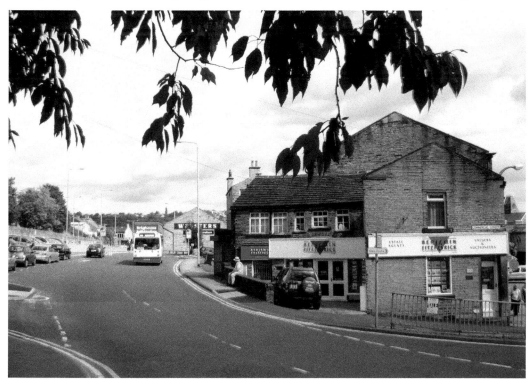

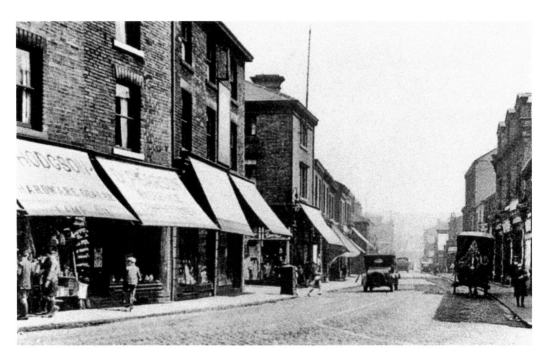

Commercial Street, Where Quality and Service Still Count

In 1891, Arthur Holdsworth Leach was given £5 by his father to help him start a new business in the Victorian world of photography. He opened his business at what is now Rowlands Chemist, 98 Commercial Street (the third sunblind from the left). Little did his father know that he had just put his son on the first step of creating a business that would become a major employer in Brighouse as A. H. Leach & Co. Ltd. This company is Leach Colour today, which is based just over the Brighouse boundary in Huddersfield.

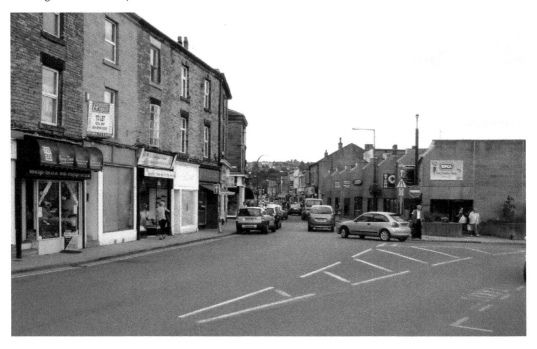

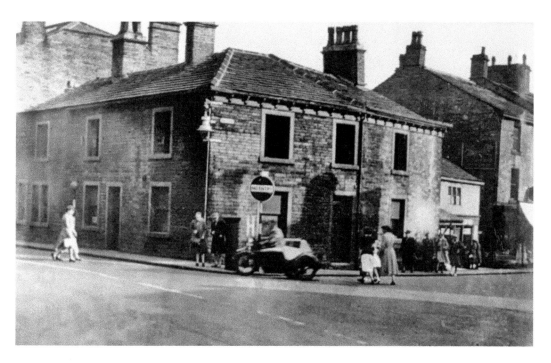

Where the Wellington Arcade Got its Name From ...

The Wellington Hotel, a few months before it was demolished in 1949. It was through the windows of this hostelry that large fence posts were thrown like javelins, when, along with other premises with an Irish licensee, it was attacked during the Irish Riots of 1882.

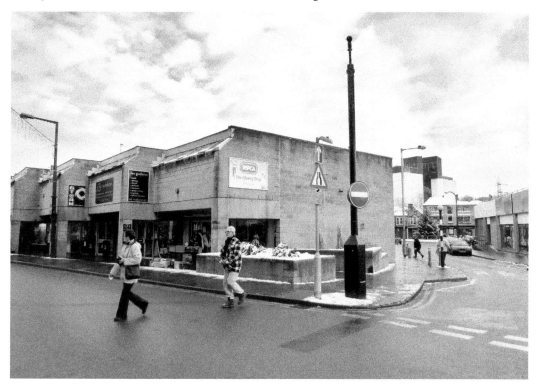

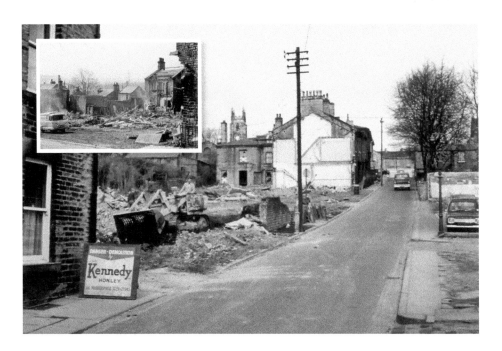

Church Lane

Church Lane is barely recognisable from the major demolition work being carried out. The new bypass cut through the middle, and the remaining space became a large town centre car park. I am sure many older readers who attended St Martin's Secondary School at the top of the hill will recall that once the school bell had gone for the day it was literally a race to the bottom to catch a bus home. For those readers who may recall, the first right was Heaton Street followed by Gooder Street.

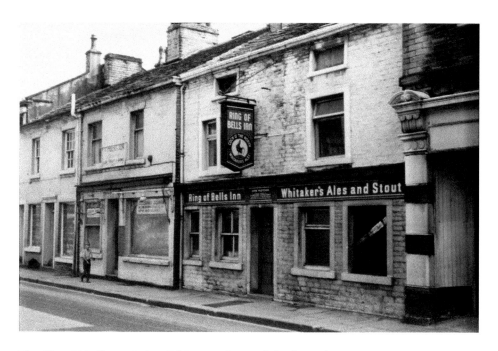

The Ring O' Bells – a Colourful Reputation Back in the 1960s

This modern scene in Commercial Street is part of the Wellington Arcade, a shopping complex that takes its name from the Wellington Hotel, which stood on the site until its demolition in 1949. The Ring O' Bells public house, and Frank Stock's Cash Stores fruit and vegetable shop next door (*inset*) were both swept aside in the early 1970s as part of the new town centre redevelopment.

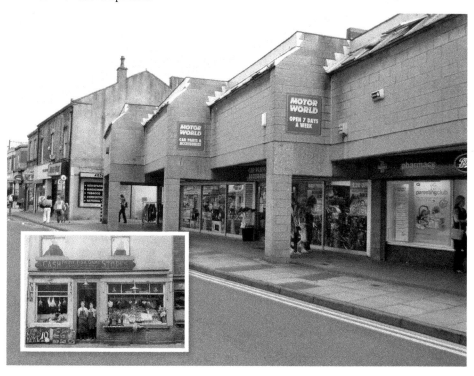

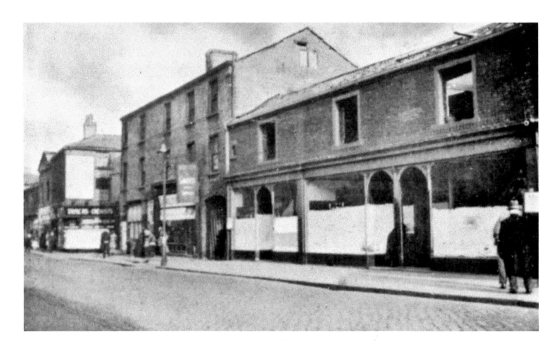

Retailers May Come and Go ...

This section of Commercial Street has seen many changes, with familiar high street names having come and gone. Names that have included the Army and Navy Stores on the corner of Market Street; F. W. Woolworth, a double-front shop that generations of schoolchildren visited to buy pens, crayons and colouring books, the Merrie England café, which is still there; Fawcett's, a stationer's and card shop, and then Burton's. In later years, this high street gents' outfitters shop became the YEB showrooms, and is now a bank.

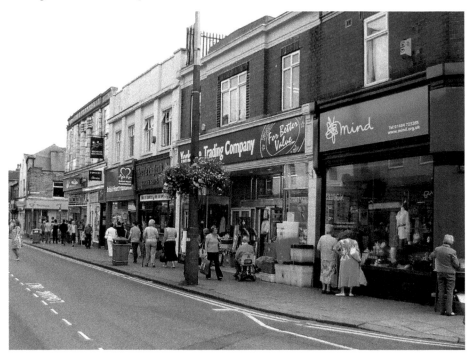

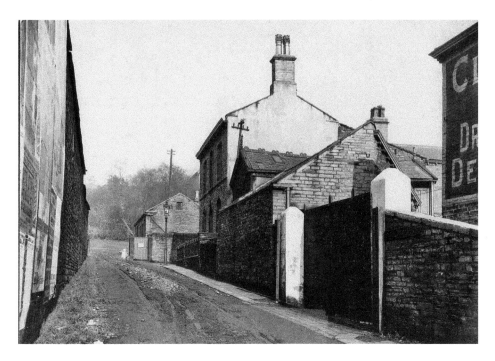

Hutchinson Lane – Surviving the 1960s and 1970s

Named after a nineteenth-century local worthy, Hutchinson Lane is now a busy thoroughfare leading from the hustle and bustle of Commercial Street to the relative calm of the new bus station. This is a far cry from fifty years ago, when it led to the narrow back streets of old terraced properties in Oxford Street and Upper Oxford Street.

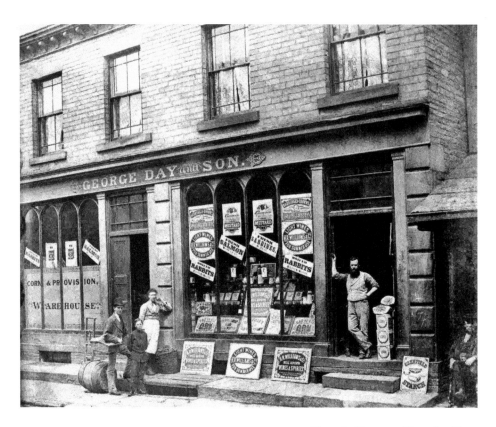

There's Always a Place for Fine Wine in Brighouse

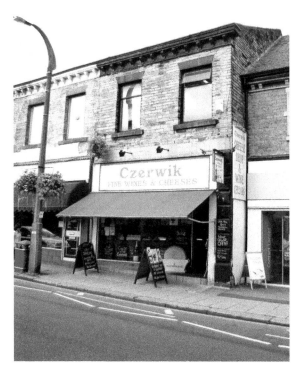

The only thing that really separates these two retail outlets is almost 125 years. They both retail fine imported wine and spirits, and they both sell specialist food. All the advertisements in George Day's shop window, and on the pavement, are advertising H. R. Williams & Co. Fine Wine and Spirits. He died in 1881, and had worked tirelessly as a campaigner for the poor. But which section of society would be his most regular customer? Most probably the poor.

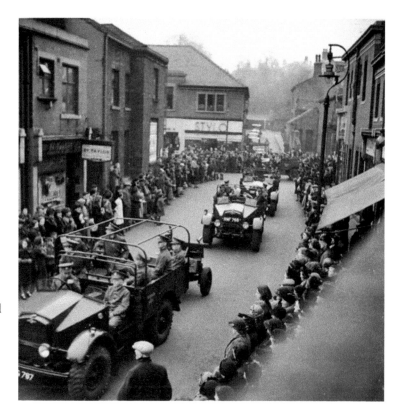

Wartime Memories in Market Street This Second World War military procession makes its way through Market Street to what was the open market area, where Wellington Arcade stands today, with not a civilian motor vehicle in sight. Had they been told to park elsewhere that day, or was it just the case that there were no motor cars in town?

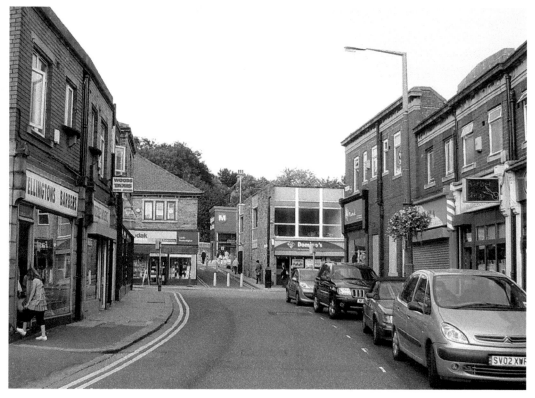

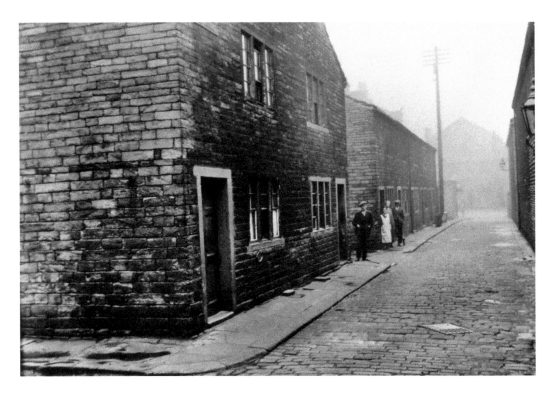

Back Bonegate, *c.* 1930s

The dark and dismal terraced properties of Back Bonegate, during the 1930s, property that was later swept away in the interests of progress. Following the closure of the Market Street bus station, *c.* 1970, it was moved to its present site. However, bus travellers had to wait until 10 May 2009 before the new one, costing £2.38 million, was completed and opened.

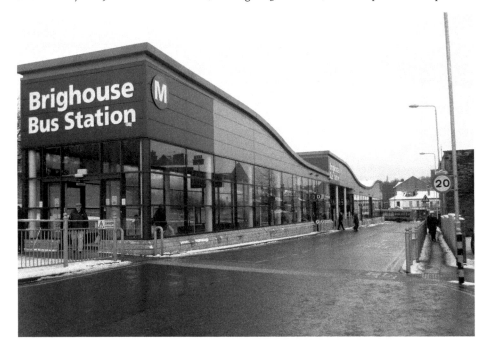

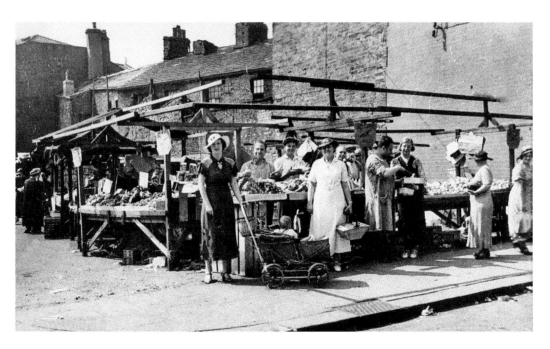

A Day Out Shopping for the Rawlinson Family

A real family outing to the Brighouse market, during the late summer of 1936. The baby, Derek Rawlinson, would not have cared what price the carrots or cabbages were. Nor does he remember, looking back almost seventy-five years later, anything about that particular day out with his mother Annie Rawlinson, *née* Gill, or his grandma Mrs Olive Rawlinson, *née* Cookson.

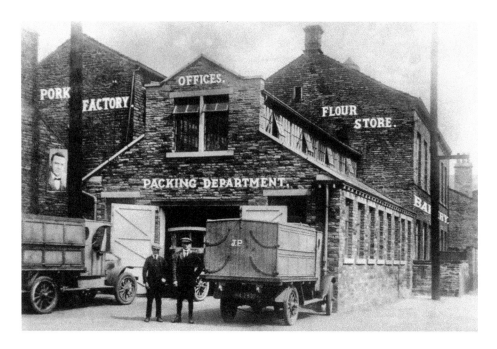

J. P. 'The Great Provider'

Joah Pearson, or J. P. 'The Great Provider' as he was often referred to, was born in Brighouse in 1874, and began his working life as a telegraph boy at the age of twelve. He went on to work in the printing trade, which eventually saw him buy out the business, and own a newspaper. But, his real business acumen went into owning a very successful bakery business, which can be seen in the older of these two photographs in Market Street. In later years, these premises were the home of Willart's car accessories, and then the more familiar name of Eurocar.

Commercial Street Before the Motorcar Era

Town centre shopkeepers may change, shopfront styles may change, but the width of pavement on this side of Commercial Street often causes comment, compared with the opposite side, because of it being a lot narrower. The shopfronts on this side of the road used to have bow or boxed fronts, but as the styles changed they were removed and altered to the more familiar flat-fronted style. However, the land the old shopfronts were built on is still owned by the individual shops, thus making it quite legal to sell goods from stands on their land, unlike those on the opposite side who can't.

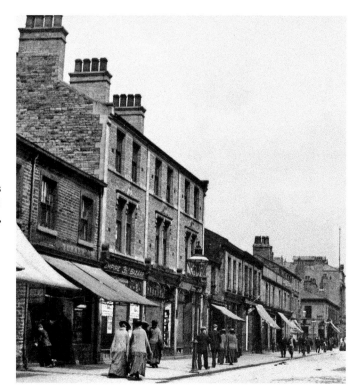

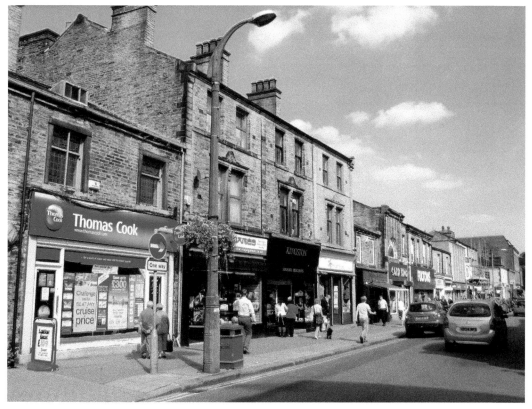

1934, the Full Monty Comes to Town

The nineteenth-century property known as Zingo Nick will be a name few readers are familiar with. It was here that many Irish labourers lived, in what were damp, squalid, common lodging houses. The Brighouse Irish Riots of 1882 at one stage were centred here, with most of the Irish men either beaten up, or chased out of the town. In the 1930s, the replacement building was itself demolished, making way for the new Burton's outfitters. Few town centre shoppers will have spotted the 1934 foundation stone in Park Street. The inset photograph is Mr Leonard Fuller, who was appointed as the shop's first assistant manager, and lived in the town most of his life, just as his family still does today.

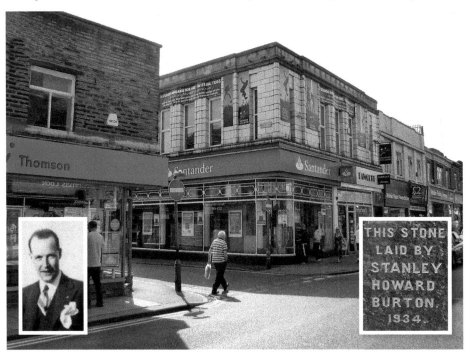

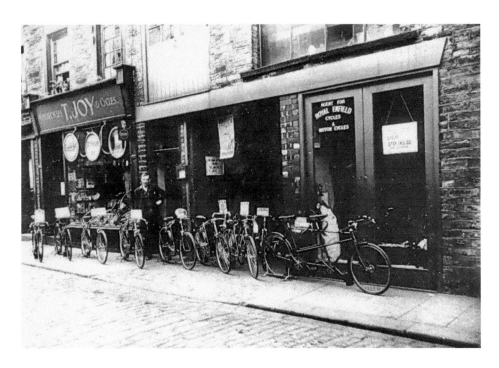

Tommy Joy's Cycle Shop, Park Street

The name of Tommy Joy's cycle shop was, for most people, synonymous with the Astoria Buildings property in Briggate. So it will come as a surprise to find the cycle shop here in Park Street. In more recent times, this shop was more familiar to town centre shoppers as Make-Do-and-Mend, the shop where you could buy almost anything; particularly in the domestic repairs, maintenance and DIY area.

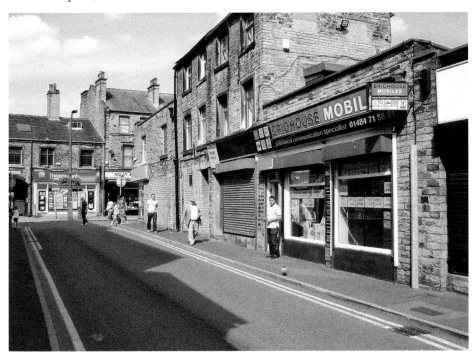

The Clifton Arms, Gone but Not Forgotten

Almost all the property in the 1930s photograph was demolished as part of a redevelopment programme. The only property that was not pulled down was the Clifton Arms, a beerhouse that was opened following the passing of the 1830 Beerhouse Act. After what could be described as a colourful history in its latter years, it was closed. In 2008, it was reopened as the Pakistani Street Food Banquet. Another century-old landmark, the Park Street post office, which had opened its doors in 1899, was closed in September 2007.

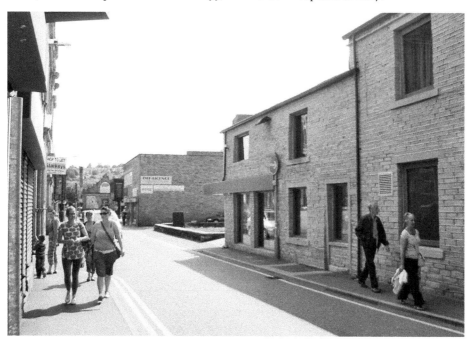

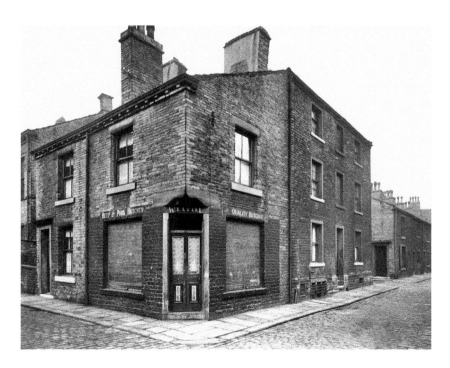

Park Street with Back Bethel Street

From butcher's shop to Robinson's Electrical and now a card and gift shop. This is a location situated just off the bustling Commercial Street. In the 1930s, the old photograph was the home of Mr Weavill and his butcher's shop, just one of at least a dozen in the town centre area back in those days. I am sure many older readers will recall the days of the wallpaper and paint shop of Stanley Crabtree on the opposite corner. Although the older picture lacks the modern, fresh and inviting look that the modern shops have, one thing remains the same – the quality of service.

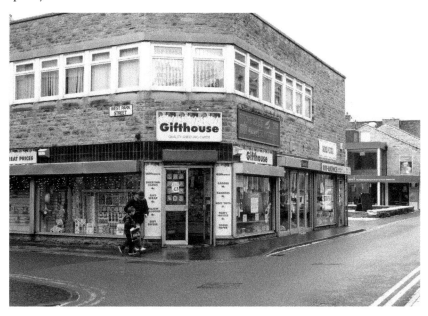

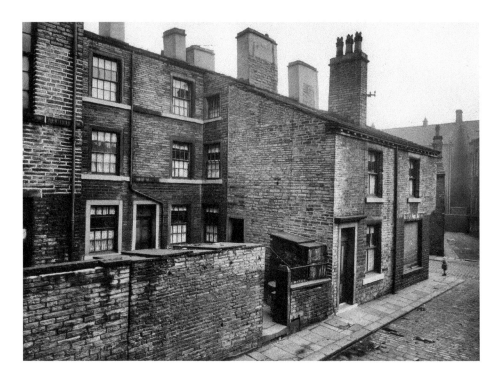

Back Bethel Street

West Park Street in the days when it was called Back Bethel Street. Note the small building in the yard next to the dustbins that was probably the outside 'facility' for that property. This was, of course, back to the days when they had whitewashed internal walls, the old Tilley lamp to prevent the pipes freezing, an endless supply of spiders, and the all-too-familiar newspaper squares hanging from a nail. And some say bring back the good old days!

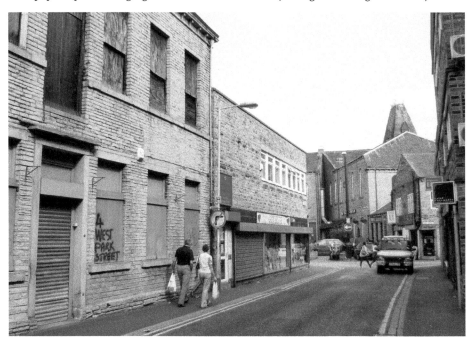

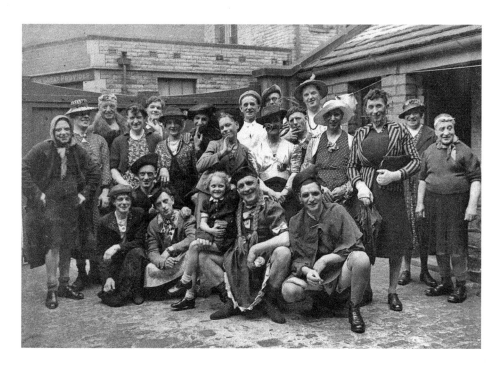

'Is That You Grandad?'

Your eyes don't deceive you, this group of men are dressed as ladies – I wonder if their great-grandchildren can recognise any of them? All these men were members of the Brighouse Home Guard Band, and are posing for this photograph in the backyard of the Prince of Wales (now The Old Ship Inn) on West Park Street (formerly Back Bethel Street). The licensee of this hostelry in those days was Tom Hunter, who conducted the band, and his hostelry was the band's regular watering-hole.

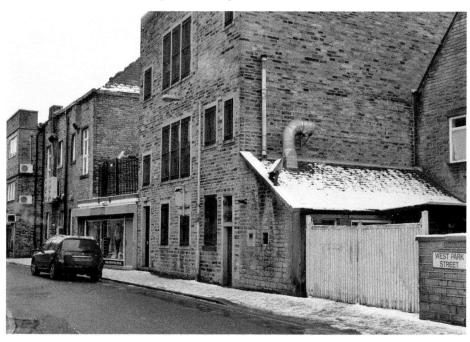

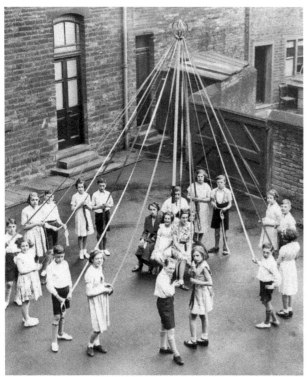

From Maypole Dancing to a Relaxing Drink

From nothing more than being the Park Chapel backyard, members of the Sunday school danced around the Maypole as part of the chapel's Diamond Jubilee Celebrations, 5 July 1938. Today, it is described as a licensed outside area and a haven for the weary town centre shopper, with the opportunity for a well-earned drink.

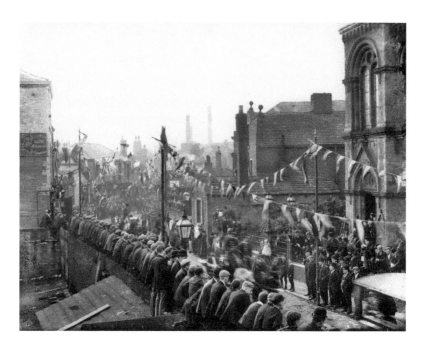

The Day Royalty Came to Town

Wednesday 22 May 1907, the very first Royal visit to Brighouse – what a day that should have been. Princess Louise, the sixth child and fourth daughter of Queen Victoria, came to open officially the new William Smith Art Gallery. Well, she did, and carried out the opening ceremony. However, having waited in anticipation of seeing a Royal Princess for the first time, she arrived and departed in a closed carriage, to everyone's disappointment.

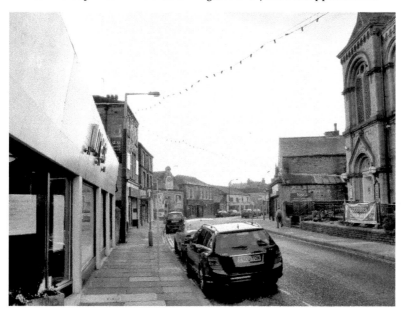

Park Chapel, Bethel Street

Now, who would have ever imagined that the former Park Street Chapel would become a public house? The chapel was converted and reopened as the Richard Oastler, on 23 November 1999. It was named after the man who, in 1820, was steward for the absentee landlord, Thomas Thornhill, at Fixby. In 1830, he met John Wood, a worsted manufacturer from Bradford, who agonised over the need to employ children in his factory. Richard Oastler became the undisputed leader of the Ten-Hour Movement, which aimed to improve the conditions of millworkers, particularly children.

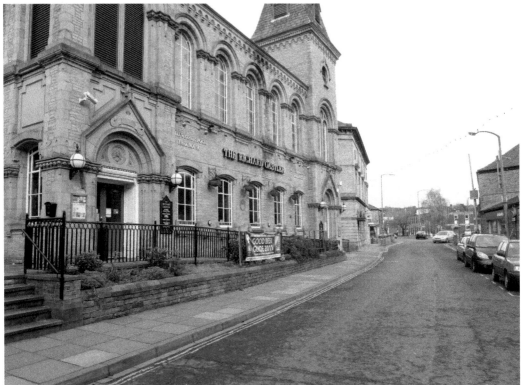

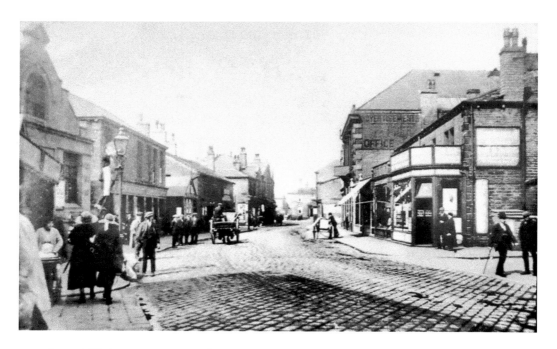

From Mill Fire to New Car Park

Little appears to have changed in Bethel Street, but in the early 1960s the members of the Borough Council had taken an adjournment in the business of the evening, having debated the ongoing parking problem in the town centre. Just where could they find additional parking space? As they looked through the first floor council chamber window, smoke was rising from Bethel Street. 'There is the next town centre car park, as the mill fire in Bethel Street raged ...' Whether true or not, it has often been said that the remains of the fire were compulsorily purchased before the embers were cold. Today it is the Bethel Street canal-side car park.

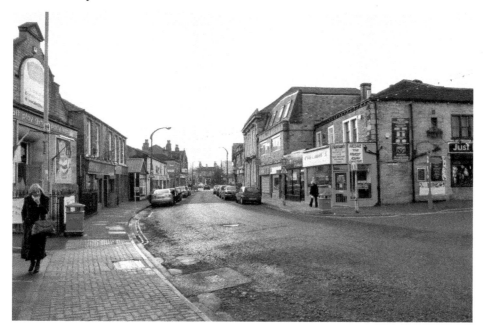

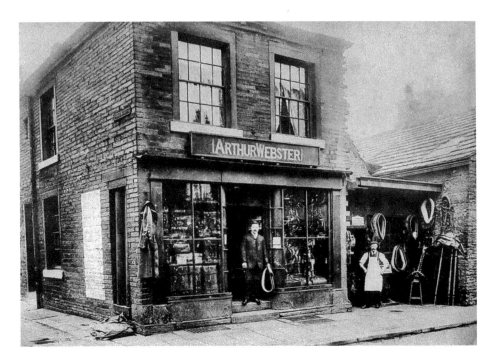

A Shop Where Quality Still Counts

The butcher and pie maker Andrew Jones' shop is at the corner of Canal Street and Bethel Street. He can proudly stand alongside Hubert Brayshaw and his mentor Tom Atkinson as one of a select group of pie makers from Brighouse whose reputation has travelled much further than the town boundary. The business is a far cry from the days when Arthur Webster not only retailed, but was a saddle and portmanteau maker.

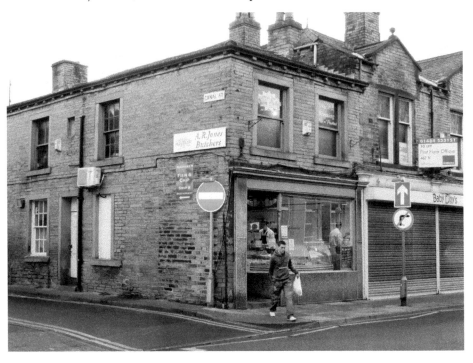

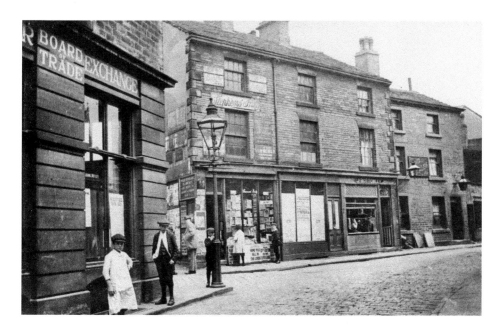

Ship or Battleship?

It is difficult to appreciate that these two images are the same scene, taken almost ninety years apart. The Prince of Wales (renamed the Old Ship Inn in 2008, and affectionately known to its regulars as 'The Battleship') is prominent with its mock-Tudor frontage. To passing observers, it is worth spending a few minutes looking at the four carvings above the ground floor windows (*see the inset*). These represent the Wisdom of the Wise, the Fool, Wine and Women, all carved by H. P. Jackson of Coley. The frontage was constructed from African oak timber, from the remains of HMS *Donegal* in 1927.

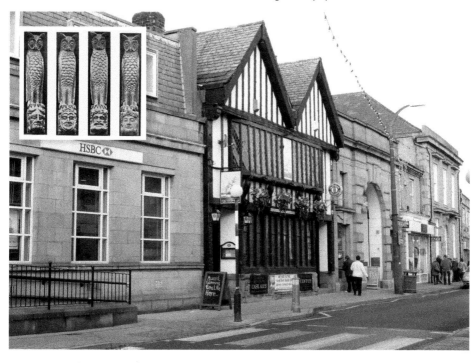

No Beverages Served Now

The Stag and Pheasant was, in 1908, just one of over a hundred premises in and around Brighouse town centre selling alcoholic beverages. Gradually, over a period of thirty years, that number was reduced quite dramatically. The Stag & Pheasant was closed in 1928, to become a retail outlet – The Bacon Shop – and in later years this also included a bookmakers. In 1955, part of the building became the new home for Ed Taylor's hairdresser's. The business was originally started in 1919, and through the diversification of the original business by the different members of the Taylor family, the name still lives on.

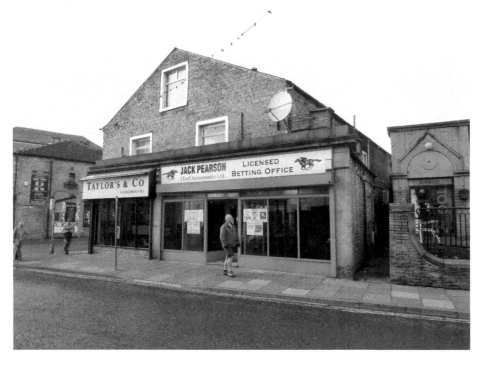

Huddersfield Road, Bradford Road, King Street and Commercial Street

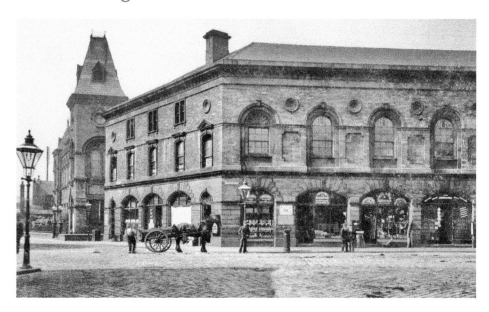

The Home of the Civic Hall

If observers look closely, high on the frontage of what was the first town centre Town Hall, they will see the date stone, 1866. It was built with eight shops on the ground floor, with the upper rooms for the town's administration offices. It was also the new home for the Brighouse Mechanic's Institute, who shared the building for many years. During its long history, it has been used as a concert hall, the home of the Savoy cinema, and in 1968 it was redeveloped and became the Brighouse Civic Hall.

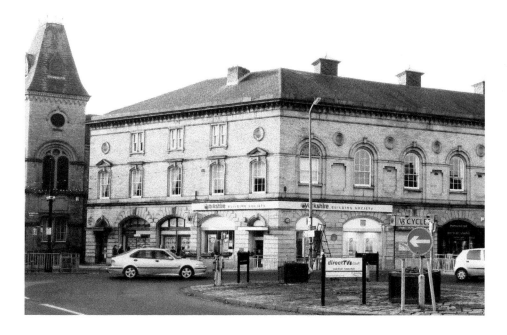

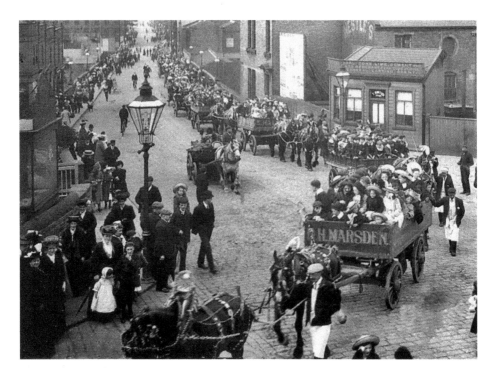

There's Nowt Like a Good Procession

The 1907 Co-operative Society Children's Treat procession, turning into Gooder Lane from Huddersfield Road. This was the day when everyone donned their best clothes for a smashing day out. The little girl dressed in her best white dress and bonnet has a front-row view, with her older brother and mother, as the horses go by. Judging from the length of the procession, it looks as though every child in the town turned out that day.

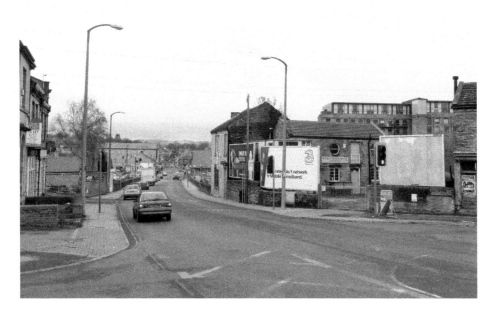

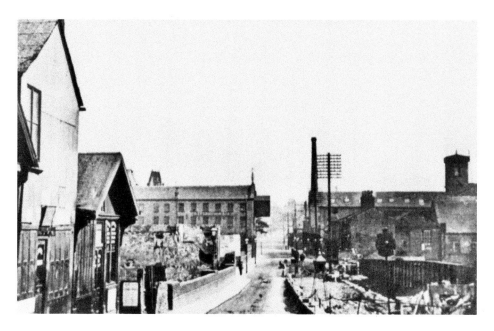

Huddersfield Road Bridge – if the Romans Could See it Now

Travelling into Brighouse, from Huddersfield, you have to cross the River Calder. In Roman times there was a river crossing point here. On the occasions of low water levels it is still just visible below the water surface. But, in more modern times, a new Brighouse Bridge was built in 1825 as part of the new Turnpike Road, and was widened in 1905. A number of plaques (*see inset*) commemorating that event are visible on the bridge. When the bridge was modernised in 1999, one of the original plaques was replaced with a new dedication plaque.

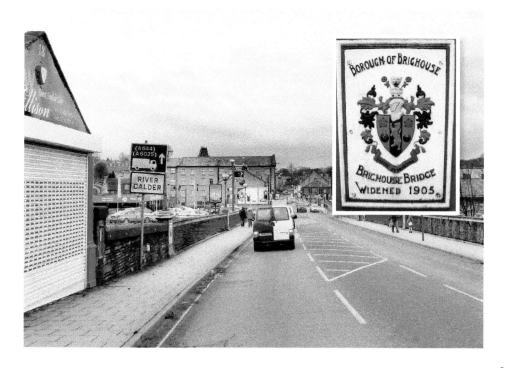

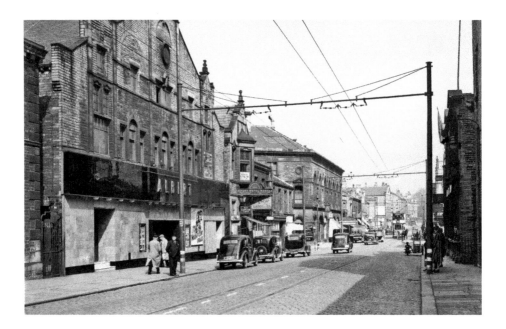

The Albert Cinema

The Albert Cinema, or 'The Ranch', as it was often referred to by the local lads, due to the number of cowboy films it showed. Many readers will remember the days of double seats at the back, and dashing out between the film ending and just before the national anthem was played. It is difficult to imagine now that this was one of three cinemas in the town centre. In 1972, it closed to become a bingo hall, and in 2003 it became the Barracuda Bar, but after a difficult beginning it was re-branded as the Calder.

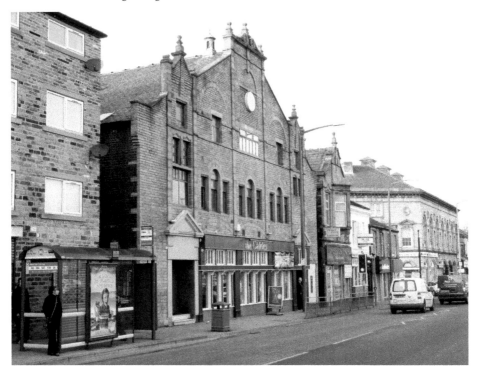

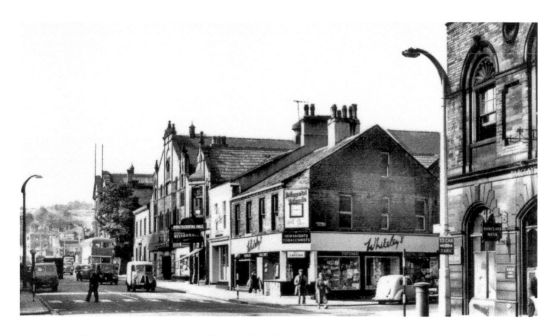

One of Brighouse's Most Familiar Landmarks

Whiteley's Corner newsagent's was opened in 1922 by Thomas Whiteley. The zebra crossing, leading across Huddersfield Road from the shop, was created in the days when hundreds of workers would pour down into the town centre after work. Many readers will recall the days of calling into Wendy's fish shop next door for a 'bag-a-chips-wi-bits', after a morning at the Albert Cinema's Saturday Star Club.

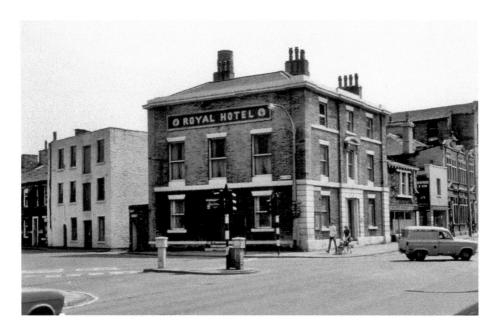

Not the Oldest, but Certainly the Biggest

The Royal Hotel, 1 Huddersfield Road, was one of the town's largest hostelries. During its long history, it was the home of many local organisations, including the Brighouse Rangers Rugby Club. Shortly after the Lighting Gas and Sewage Act of 1845 was enacted, and gas lights had been installed at the Royal, the wife of the licensee Thomas Scott noticed the smell of gas in the cellar. Whilst investigating with a lighted candle, she was badly injured in the resulting explosion and fire. The property was demolished in 1973 as part of the town centre redevelopment.

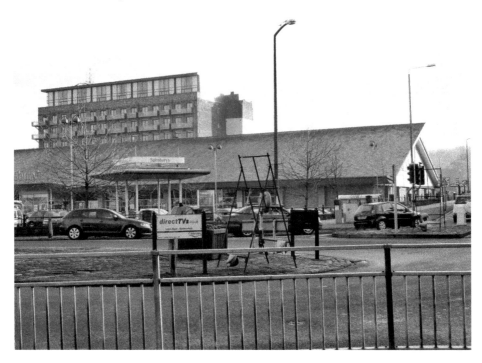

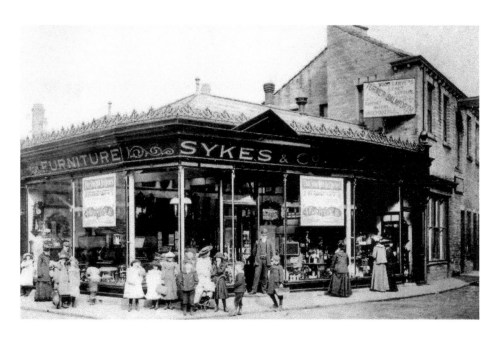

The Bypass of the Early 1970s

Sykes & Co. furniture shop stood at the junction of Mill Lane and Police Street (now Lawson Road). The people standing outside the shop are all dressed in their best clothes, which would suggest this photograph was taken on a Sunday. It was during the early 1970s when the shop and many of the surrounding buildings were all swept away in the name of progress. The junction, now a roundabout, is the gateway to the town centre from Huddersfield and the bypass that helps to relieve the traffic in the town centre.

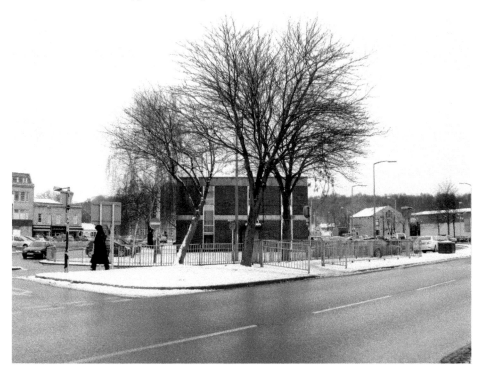

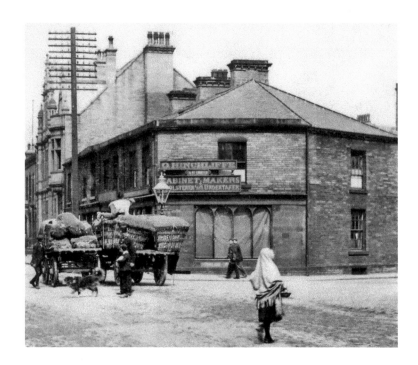

It All Started in the Cellar of this Shop

It was in the cellar of this corner shop that Joseph Blakeborough first experimented with steam valves. It was these early experiments that were to lead to the founding of a business that would be a major employer for over 150 years and become truly international. Sadly, the Blakeborough works at Brighouse was closed on 12 April 1989. During the 1960s and 1970s, the shop was Leonard's Florists and today it is Webster's Interiors.

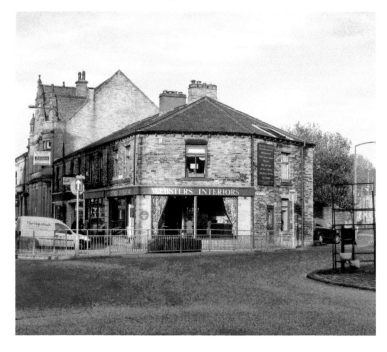

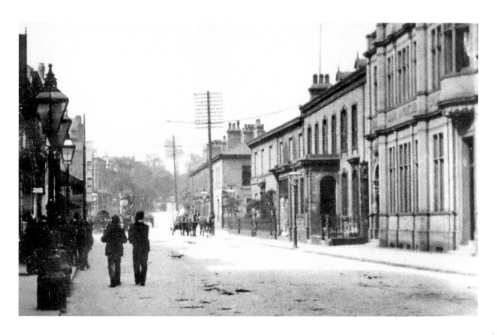

Not a Motor Vehicle in Sight

During the mid-nineteenth century, this small section of Bradford Road was known as 'Ball Flash'. Today it is a thriving part of the town centre, where many of the town centre banks have resided for over a century. Note that on the older photograph the only vehicle on this stretch of road is the horse-drawn variety, compared to the motor vehicles parked outside the banks.

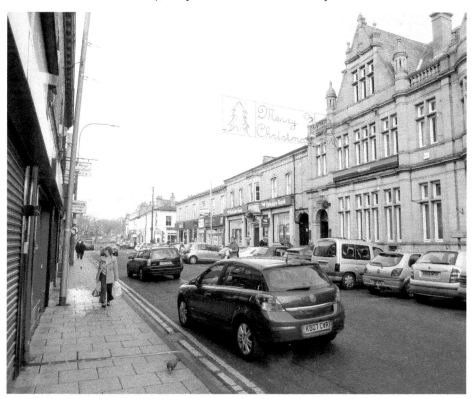

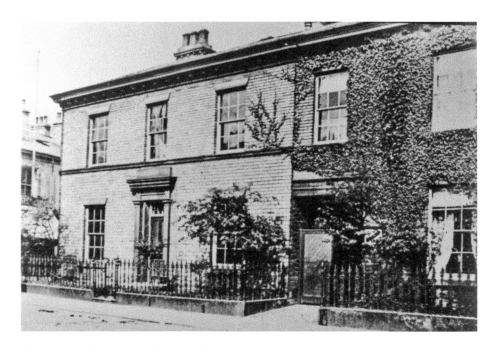

The Home of Doctors and Companies

The branch of M&Co. has been a welcome, and popular, newcomer to the town centre from the day it opened in April 2000, in the former Brighouse Co-op Menswear and Food Hall departments. Whilst the ground floor shop-window styles have changed over the years, the first-floor windows in both photographs are just the same. The building dates back to the nineteenth century, when it was a private residence for a Doctor Brown.

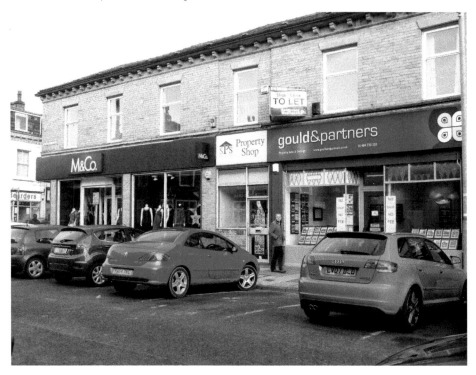

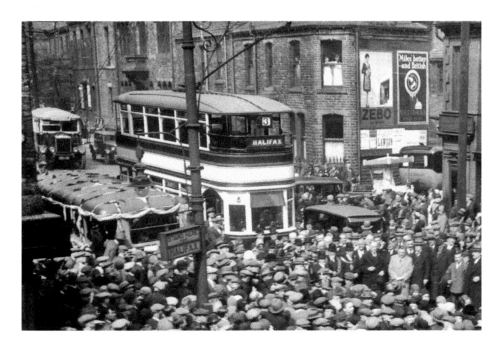

We Won the Cup

On Saturday 2 May 1931, Halifax RLFC won the Rugby League Challenge Cup for the first time since the 1904 season. This large gathering in Bradford Road, outside the George Hotel, turned out to welcome the team as part of the RLFC's triumphant tour of Halifax and surrounding towns. It is also likely that the tramcar is the last one from Halifax to Brighouse. On Wednesday 6 May, the days of the tramcar from Halifax came to an end, after twenty-seven years.

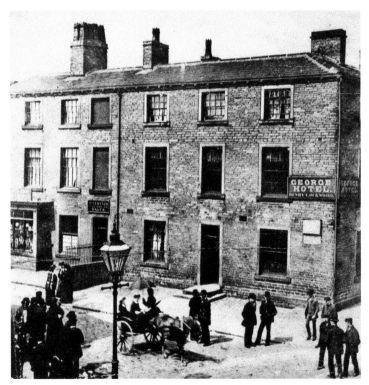

The George Hotel
It is common to use pub names as landmarks when someone visiting the town asks for directions. One of the most familiar landmarks in the town centre is the George. Once a busy and thriving hotel for weary passing travellers, over the years, like most licensed premises, it has had its high and low times. The new tramway service that arrived from Halifax in February 1904 saw the terminus of this new form of transport situated outside the pub in Bradford Road.

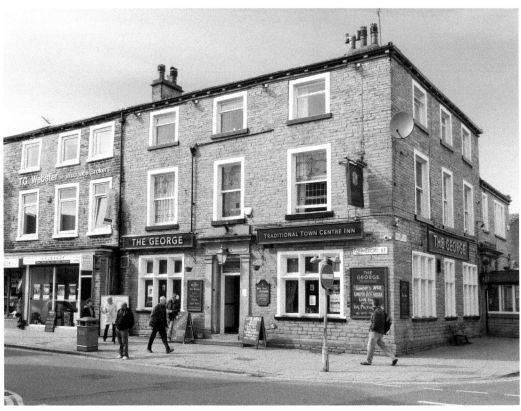

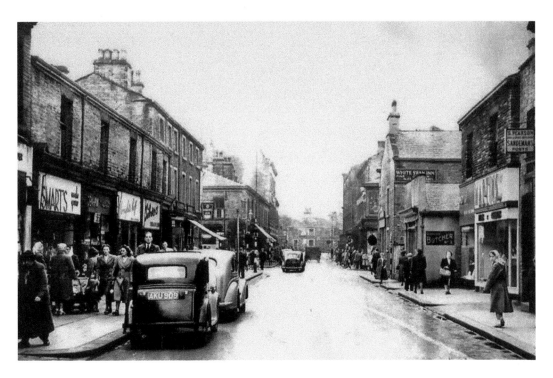

Local People Still Like to Shop Locally

You will often hear people say that little has changed in Brighouse town centre. Well, these two photographs may confirm that, but whilst the ground floor of these shops may have changed, local history in any town centre begins at the first floor. Next time you are shopping in town look at these properties and I know you will see a few surprising features.

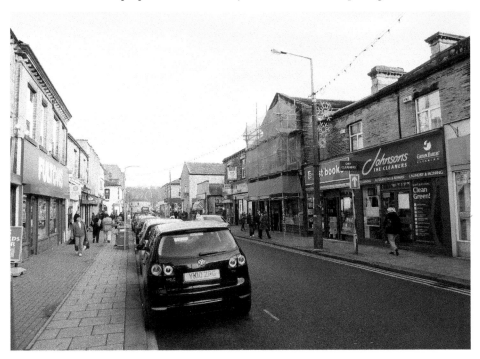

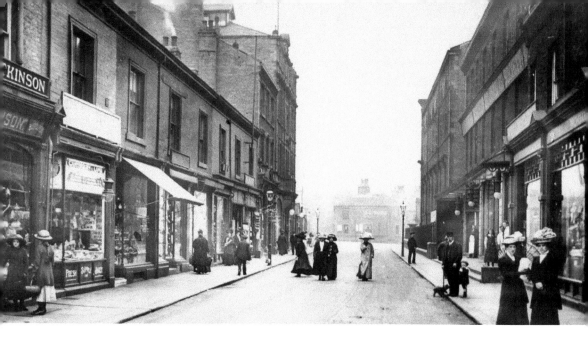

King Street with not a Car in Sight

Even though King Street was dominated by the Brighouse Co-op from the day it opened in 1856, there were other shops in the street which are still remembered today. The most memorable being Tommy Atkinson's pork pie shop, which, along with Brayshaw's pie shop on Bethel Street, sold the best pies in town. Both of these town centre shops and their pork pies were highly regarded; so much so that customers would travel miles to come and buy them.

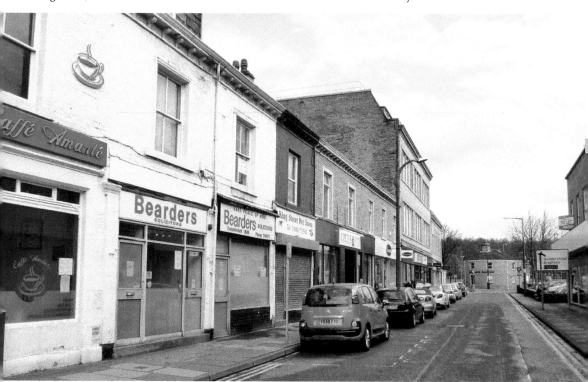

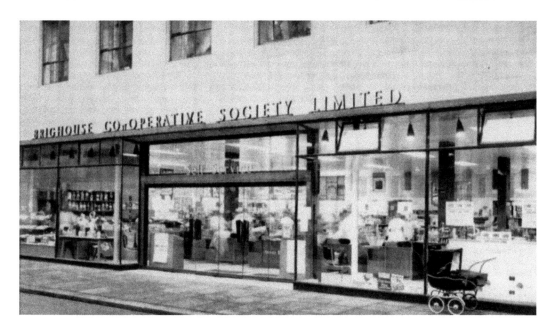

No Prizes, but Can You Remember Your Co-op Divi Number?

King Street was the home of the Brighouse Co-op, and in 1956 it opened its new self-service store in the town centre – a real innovation for Brighouse shoppers. Sadly, the Co-op was merged into the large Bradford Co-op and later closed. Today, it is one of the 300 branches of the successful clothes chain M&Co.

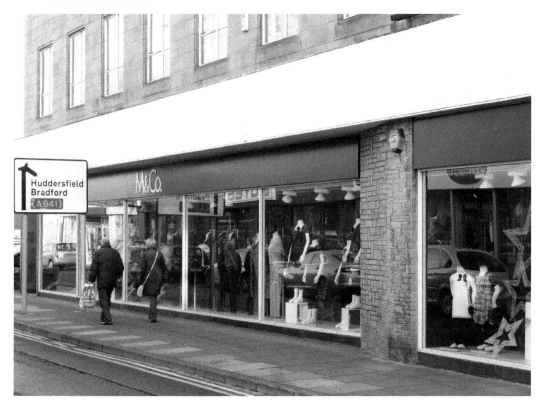

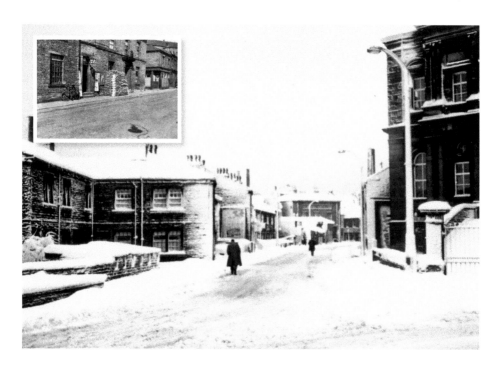

Home of the Police for Almost a Century

Although this is the same location, the snow-covered street is Police Street, *c.* 1950s, the street where the town police station stood (*see inset*) from 1864. A century later, the police station was moved onto Bradford Road and, along with most of the buildings in the 1950s street, was demolished. Following the death of Alderman Gilbert Lawson MBE in 1977, the street was renamed Lawson Road in his honour.

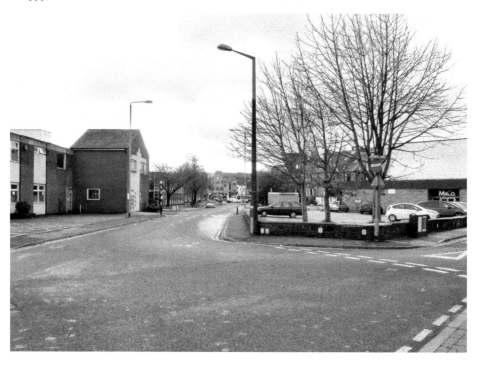

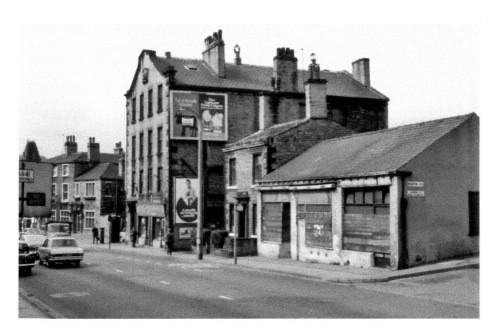

Oddfellows Hall, Bradford Road

During the town centre public order disturbances, following the assassination of local MP Lord Frederick Cavendish, on Saturday May 6 1882 in Phoenix Park, Dublin, a mob gathered at the bottom of Martin Street, the right turn on these images. The intention was to attack the nearby St Joseph's RC church and burn it down. The police prevented this, but all the church windows were smashed. The top photograph dates back to 1970, with the Oddfellows Hall dominating the scene. All the property on that side of the road was demolished as part of the early 1970s town centre bypass redevelopment.

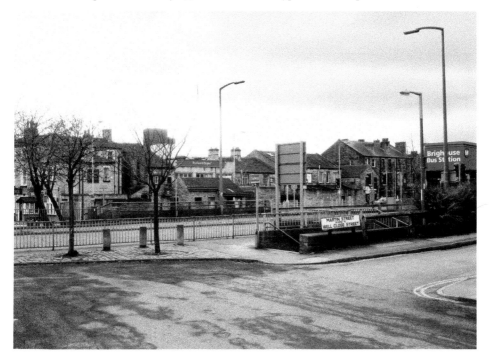

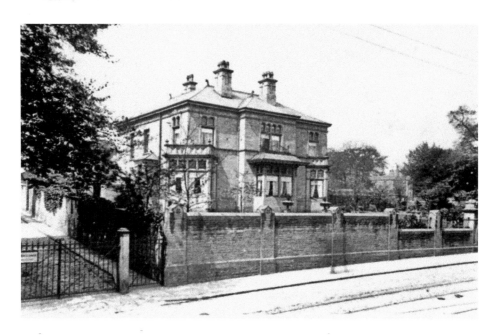

The Ritz, First Purpose-Built Cinema in Brighouse

Brooklands, the home of Dr William Skeels, was demolished for the first purpose-built cinema in Brighouse to be built on the site. It was opened in 1937 by the Mayor John Clay. With the changing fortunes of the world of the silver screen, it was closed in 1961. After a period as a bingo hall, it closed again in 1963 until, in 1965, following a change in the gaming laws, it emerged as the Casino and Theatre Club, relaunched as the Tropicana Club in 1970. Some readers may recall the days when it was again rebranded as the Stardust Showbar, but that too was short-lived. Since 1981 it has been the very popular Ritz Ballroom.

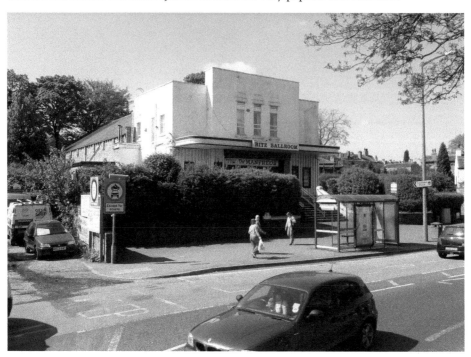